THE MEADOW

AN ENGLISH MEADOW THROUGH THE SEASONS

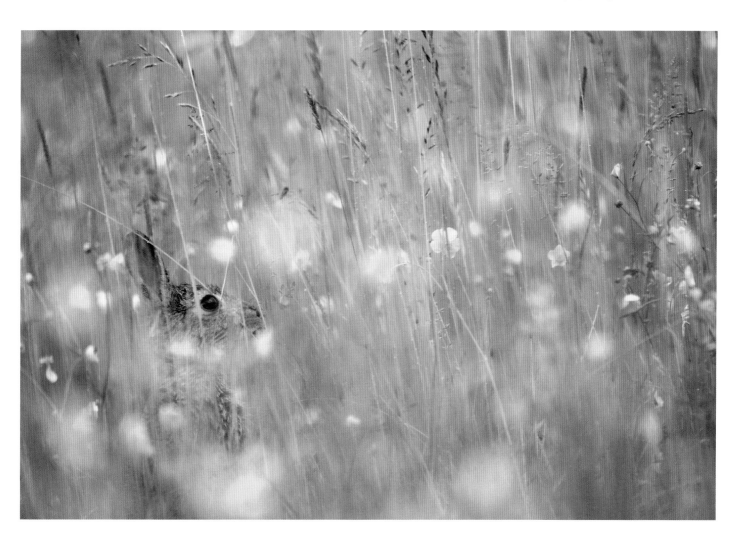

THE MEADOW

AN ENGLISH MEADOW THROUGH THE SEASONS

F

FRANCES LINCOLN LIMITED

PUBLISHERS

To my family. Without their support, patience and love none of this would have been possible. Also, to Alice. Never was there such a beautiful girl completely covered in hair.

Frances Lincoln Limited
4 Torriano Mews
Torriano Avenue
London NW5 2RZ
www.franceslincoln.com

The Meadow
Copyright © Frances Lincoln Limited 2012
Text and photographs copyright © Barney Wilczak 2012

A catalogue record for this book is available from the British Library.

ISBN 9780711232723

Printed and bound in China
1 2 3 4 5 6 7 8 9

PAGE 1 European rabbit (*Oryctolagus cuniculus*)
PAGES 2–3 Meadow silhouettes
THIS PAGE Clouds turn pink as the sun sets over the meadows

Contents

Foreword 6

Introduction 8

1. Spring flowers 28

2. Birds and habitat 42

3. Orchids 60

4. Invertebrates 80

5. Seed and fruits 104

6. Maintenance 118

How you can help 127

Index 128

Foreword

Wildflower meadows are one of the UK's most wildlife-rich and colourful habitats. They provide a living connection with the landscapes of our past – as valuable and life-enriching as any work of art or museum exhibit.

Standing in a meadow surrounded by wildflowers, butterflies, birdsong and the hum of insects, it's hard to imagine there is anywhere else that you can feel so close to so much nature. Yet the decline in wildflower meadows means that few people of my age have ever had this experience.

The statistics are grim. In the last fifty years, despite efforts to protect the most valuable sites, we have lost around 97 per cent of our lowland meadows and there are now fewer than 15,000 hectares remaining in the UK. As a comparison, while our ancient woods have suffered terribly too over the same period, around half the area of forest we had in the 1930s remains, compared to just 3 per cent of our wildflower meadows.

Our remaining meadows are vital havens for wildlife, surviving islands for many threatened or declining species. Across the UK, The Wildlife Trusts are responsible for protecting and managing some of the country's finest wildflower meadows, from upland hay meadows in the hills of Cumbria and County Durham to flower-strewn fields on the banks of the River Thames. Many of these places have been saved from destruction by Wildlife Trusts, and traditional land management practices, such as grazing and hay cutting, enable them to continue their colourful yearly cycle.

Clattinger Farm, owned and managed by the Wiltshire Wildlife Trust since 1996, is such a place. It provides a glimpse into a past when flower meadows were a common sight in the landscape, and it also gives us reasons to be positive about the future. Clattinger Farm is part of the wider Braydon Forest Living

Landscape area, the Wiltshire Wildlife Trust's large-scale initiative to restore wildlife habitats such as woods and meadows across the whole landscape. As well as providing valuable open space for people to enjoy, this work will help to protect and restore wildlife – the wildflowers, bats, butterflies and birds – that rely on a healthy network of suitable habitat.

Today Wildlife Trusts across the UK are taking action to restore, recreate and reconnect wildflower meadows. At Chimney Meadows in Oxfordshire the Berks, Bucks and Oxon Wildlife Trust has restored 70 hectares of arable farmland to species-rich meadow. Encouragingly, its research has shown that with the right management species diversity can be increased relatively quickly. The Nottinghamshire Wildlife Trust has devised a way to bring the colour and vibrancy of meadow flowers into towns and cities. Its mini-meadow scheme encourages people to create their own small-scale meadows in gardens and even in window boxes, so creating new wildlife habitat where it is often much needed.

I hope Barney Wilczak's wonderful book inspires to discover your local wildflower meadows, wherever you live.

Stephanie Hilborne OBE
Chief Executive

Introduction

A rich blue dominates. A tangle of indigo, violet, royal and navy. Trembling leaves indicate the rising temperature and resulting breeze. The skies are cloudless. Mist rises from the meadows' surface to both obscure and highlight the multitudinous forms as condensing droplets adhere to their surfaces. Their shapes are revealed as taught wires, cups, paddles, feathers, tails, hearts, flags and countless other structures. Insects become visible, their legs clasped rigid. They hang like jewellery, motionless, with the defining drops refracting the twilight. The transparent wings of dragon- and damselflies are heavy; the fine hairs and scales of butterflies are saturated; the compound eyes of flies and beetles are furnished with dozens of additional lenses. Yet the insects remain still, for the cool morning air does not provide the warmth they require for motion.

In a moment the early summer scene changes. The deep blue of the sky softens, becoming dilute and pale. The stars fade and the wash of colour becomes warm. Before I see the sun I watch the tops of poplar and willow take on the colour of burnt sugar. Soft, enveloping, it slides downwards over the bark. It catches the leaves, so that one side is hard and alive, the other obscure in their blue shadow. Next the sun pushes through the hedgerows, thick walls becoming translucent, showing a hint of the tracery of branches. The rhythmic calls of birds blend in a disharmonious chorus. Deep orange penetrates the breaks in the blackthorn and hawthorn and the mist radiates incendiary streaks.

The sun rises higher, pulling the shadows back towards the meadows' boundaries. In the changing light new colours emerge. Small highlights of blue remain: violet tufted vetch, indigo devil's bit scabious and rush leaves of cool marine green. But the tangle of blue is gone. A blend of cream, purples, gold, green, pinks and ochre has replaced it. As I look across the fields I see that the colours separate into distinct areas. On closer inspection I see the blurred edges and the dozens of shades and pigments of which they are composed. As the mist thins, removing the diaphanous softening, each colour deepens.

As the air warms, the wind picks up, swirling the remnants of vapour. Wing markings become luminous, and the wings' surfaces twitch and stretch under the increasing radiation. Legs are moved, stiff and unsteady. Within only a few minutes the air around me becomes thick with insects. Not yet experiencing the optimum temperature for them, they are cautious at first; their flight is laboured, their sorties short. Taking off from their night-time roosts, damselflies move to the next perch. Butterflies investigate low corridors through the vegetation. As the insects warm up, they begin to rise upwards until dragonflies are hovering like hawks above the hedgerows, watching for flies and beetles circling

outwards. Groups of butterflies tumble over the surface of the meadows and all the pollinators – beetles, flies, bees and wasps – set to work again.

The birdsong is replaced by the drones and percussive drumming of insects and the birds – their territories now defined – descend. Some feed on seeds and fruits; others pick among the plants at the newly awoken invertebrates. A hobby hangs above, slicing with its sickle wings to intercept the predatory dragonflies.

Each niche and resource of the meadows is filled with activity. As I watch a four-spotted chaser pass, my movement brings the rabbits circling the meadows to a bipedal alert. They stand with their backs to coarse tunnels through brambles, the routes to their burrows. This cage work protects them against the foxes that run with fluid movement tight against the meadows' borders. With the wind bearing my scent and confirming my presence, they twist hard, swinging their bodies to dive back to safety. I find scrapes left by badgers as they search for grubs and worms. Paired crescent slots in the soft mud around the streams disclose the presence of roe deer. With their summer pelts a rich and golden brown, these stand slight, elegant and feminine. More sensitive than the rabbits, they watch from a distance, eyes staring, ears twitching and tongues circling their noses as they try to catch a scent. Then they slip away before being seen.

Each moment here is so fast and intangible that a conscious effort has to be made to experience it. Those things that can be observed for an hour are lost in a few minutes, to be replaced by a hundred alternative sights. And in an hour or two this hay meadow has once again transformed. A day spent here is not enough. With each passing week the scene shifts, and the colours and the environment change almost beyond recognition. Yet its biodiversity means that each part is connected to and reliant on another.

I first encountered these meadows, known as Clattinger Farm, on an organized walk. Our aim was to see the thousands of orchids that bloom here every summer. The meadows are owned by the Wiltshire Wildlife Trust, a part of the national Wildlife Trusts, a charity that works to conserve the UK's natural heritage. Its aims include addressing the ways in which we can sustain the rich biodiversity our landscapes have had and in many areas still contain.

The local warden introduced us to a handful of fields of spectacular variety. Plants recognized as rare spread in drifts before us. Great burnet, green winged orchids, southern marsh orchids, devil's bit scabious and adder's tongue fern – these and many others told of why these are considered to be one of the finest remaining examples of lowland hay meadows in the UK.

We soon discarded the wider views to investigate details. These went beyond the flowers' infinite colours. Stiff hair, soft down, delicate projections, coarse spikes, forms beyond the comprehension of any architect that hung staggered, open and emerging, along stems: here in these flowers was variety of an extreme nature, and our appreciation of it was enhanced by the knowledge that each flower had emerged from a minuscule basis, and was continuing a cyclic pattern, every aspect of it interlocked with the habitat around it.

I made repeated visits to the meadows and, observing them through the seasons, experienced a flood of discovery. The tidal progression of species spreading and receding, integral to the nature of the hay meadow, stood in marked contrast to the stark monoculture of modern agriculture.

Hay meadows have had a particular hold on our view of Europe. The romantic poets expounded on the changing drifts of flowers. Artists were repeatedly drawn to the use of pastureland and the hay making that typified rural life in the past. Authors wrote of fields humming with insects – a description I maintained in my mind as a glib exaggeration until that first summer when I experienced a rich droning throb emanating from the ground, with no individual source, as if the soil and roots were vibrating, and as we moved through the mixture of wild flowers and stunted grasses waves of grasshoppers, beetles, froghoppers, butterflies and innumerable other insects lifted around us.

High-quality meadows are a natural occurrence; indeed across much of Europe and beyond they still exist. With the right amount of grazing by wild animals, preventing the establishment of shrubs and trees, such pastures thrive; in this respect alpine meadows are helped by the fact that they are above the tree line. But today the reason for their richness, their biodiversity, lies not just with nature but also with people.

With wide deforestation and agriculture the landscape of the UK changed over the centuries beyond recognition. The development of a farming nation – made possible by a mild climate and a landscape amenable to it – created a rural mosaic, with stone walls and thick regular hedgerows lying like cracks between each tile. Taking over the role of wild grazers, farmers took to using land as pasture; small herds of cattle and sheep moved between different fields, cropping the grasses and countless herbs. The meadows sustained themselves without ploughs and with only the addition of the animals' manure, but the farmers worked with the natural cycles of growth, allowing flowering plants time to set seed, so ensuring regeneration, and feeding the animals hay cut in late summer in these rest periods. The meadows were even used sometimes as a form of common land, the owners cutting the herb-rich summer hay and opening up the land to others for autumn and winter grazing of livestock.

Although some of the meadows came about from destructive behaviour, man's changing of the landscape allowed these habitats to thrive. Adapting to the changes, many birds used the hedgerows as corridors, travelling, feeding, breeding and nesting along their lengths, while yellow wagtails, their tails alive, flocked to the dung of the increasing numbers of livestock to grab the insects that bred there. Insects, seeds, fruits, flowers and habitat of the hay and floodplain meadows, washed by the invigorating silts of streams and riverways,

also satiated birds. Plants gave by providing richness of diet and themselves benefited from the maintenance of the landscape. Insects, including many specialists reliant on a few food plants, had the environment they needed, while their survival ensured a plentiful source of food and pollination. Each element – including the farmers who made a living by grazing livestock and cutting hay – lay in its place, as part of a pattern, supporting the others.

This traditional approach to farming has other benefits. Undrained, floodplain meadows hold large amounts of water and act as a valuable overflow for flooding elsewhere. This in turn creates the habitat needed by specialists such as great burnet, rushes and the almond-scented meadow sweet. The unploughed soil and lack of herbicides allows the establishment of slow-growing perennials, richly interspersed by annual wildflowers.

Yet today the hay meadow is all but gone here and it faces threats throughout Europe and beyond.

The photographs in this book illustrate a place of extreme beauty, contrasts and importance. In a few short written vignettes I will explore some of the things that make this and similar habitats so enchanting and look at the future they face.

Barney Wilczak

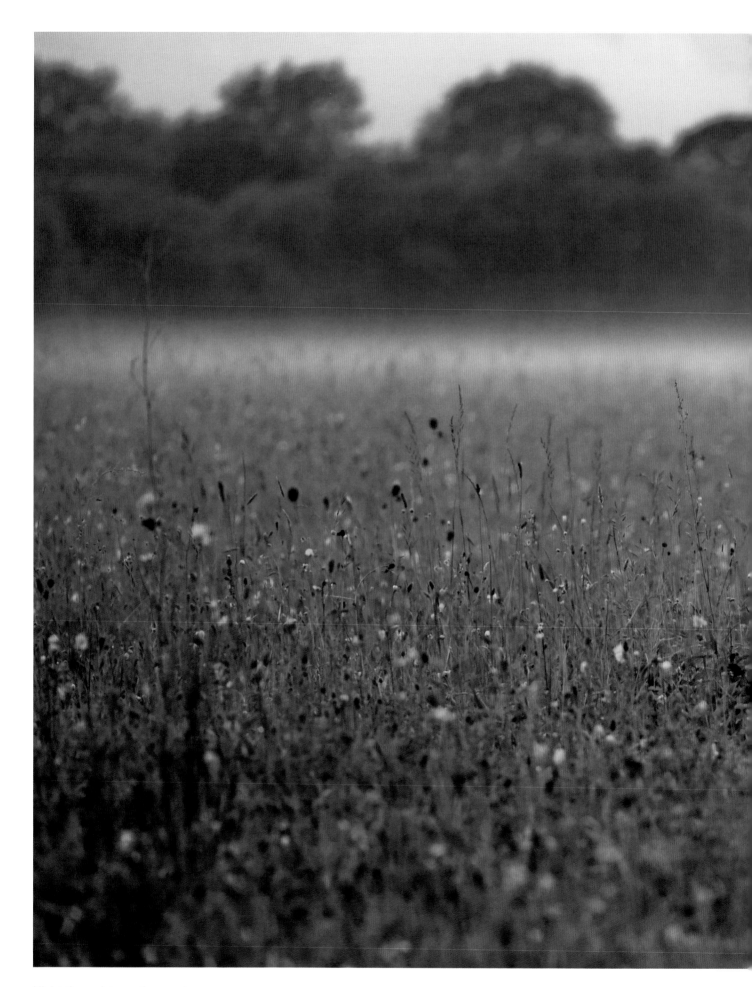

Night-time mist over the meadows

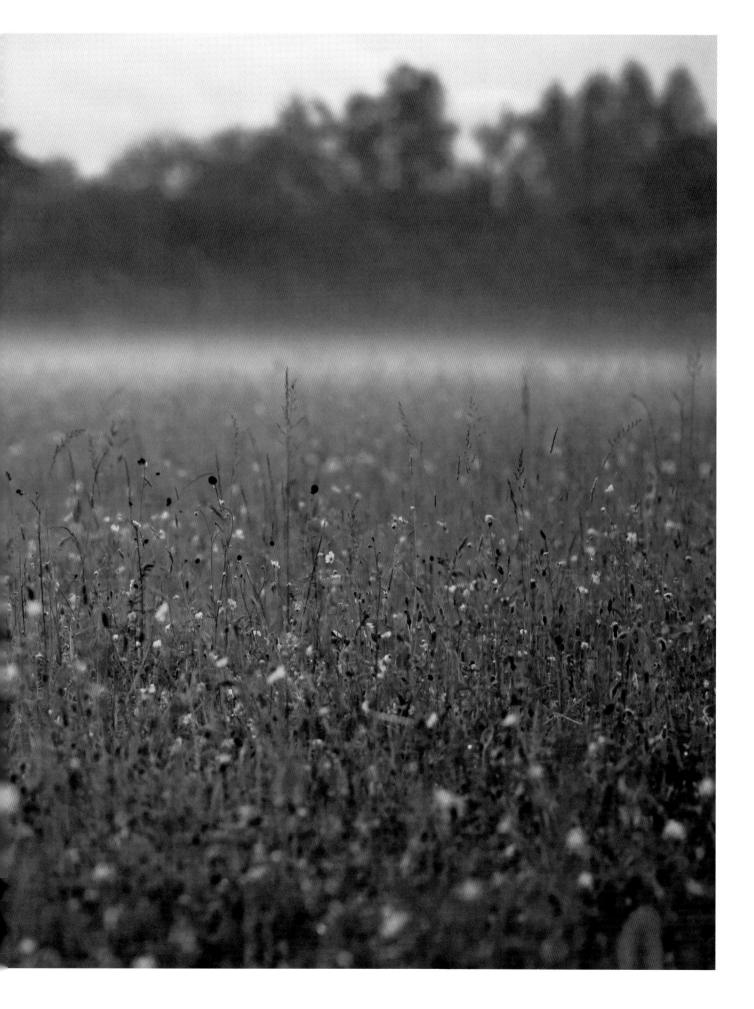

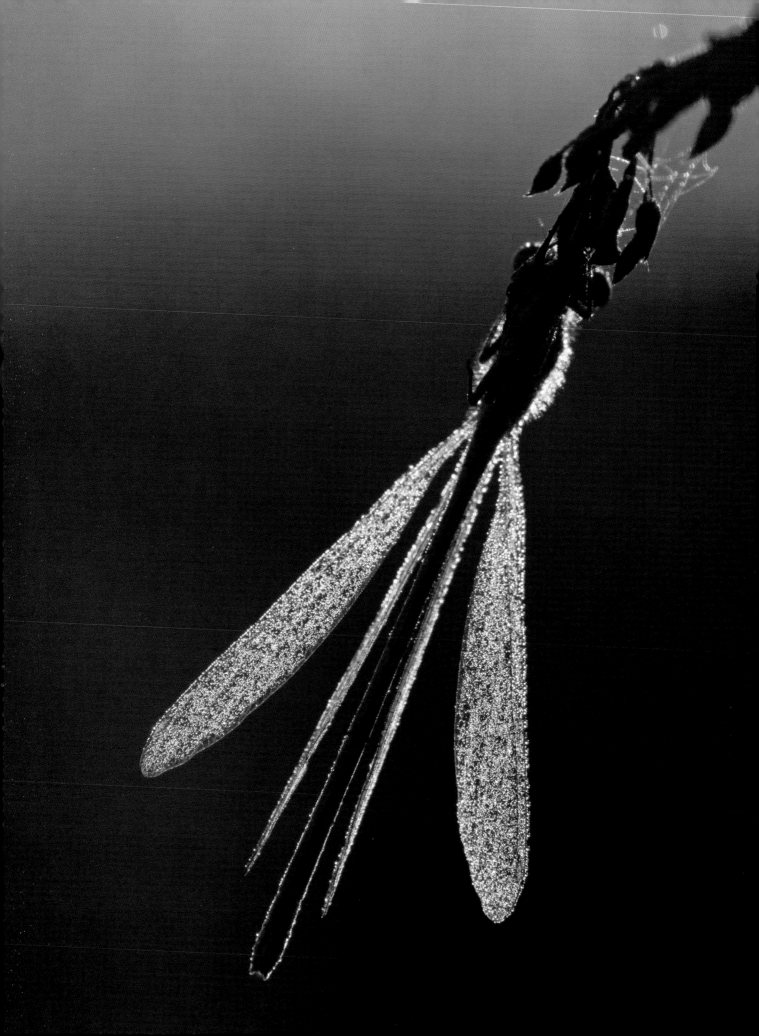

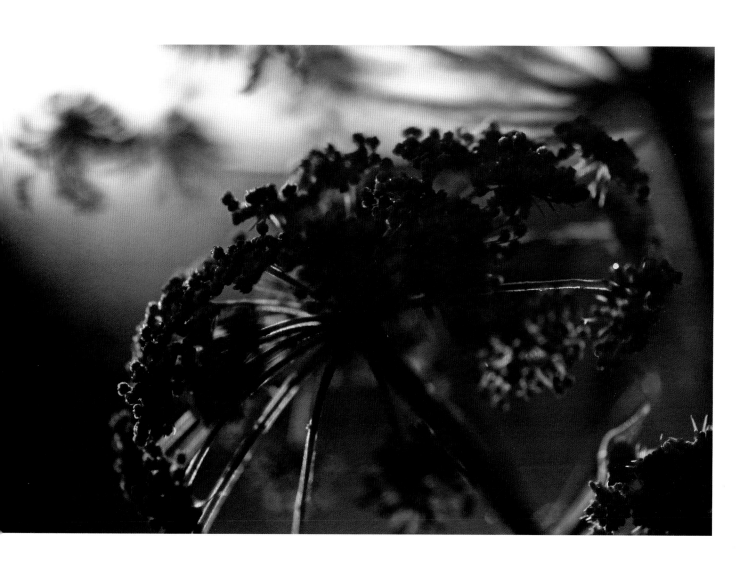

LEFT Common blue damselfly (*Enallagma cyathigerum*), covered in droplets from the morning mist
ABOVE Hemp agrimony (*Eupatorium cannabinum*)
FOLLOWING PAGES Common blue damselfly (*Enallagma cyathigerum*), in flight

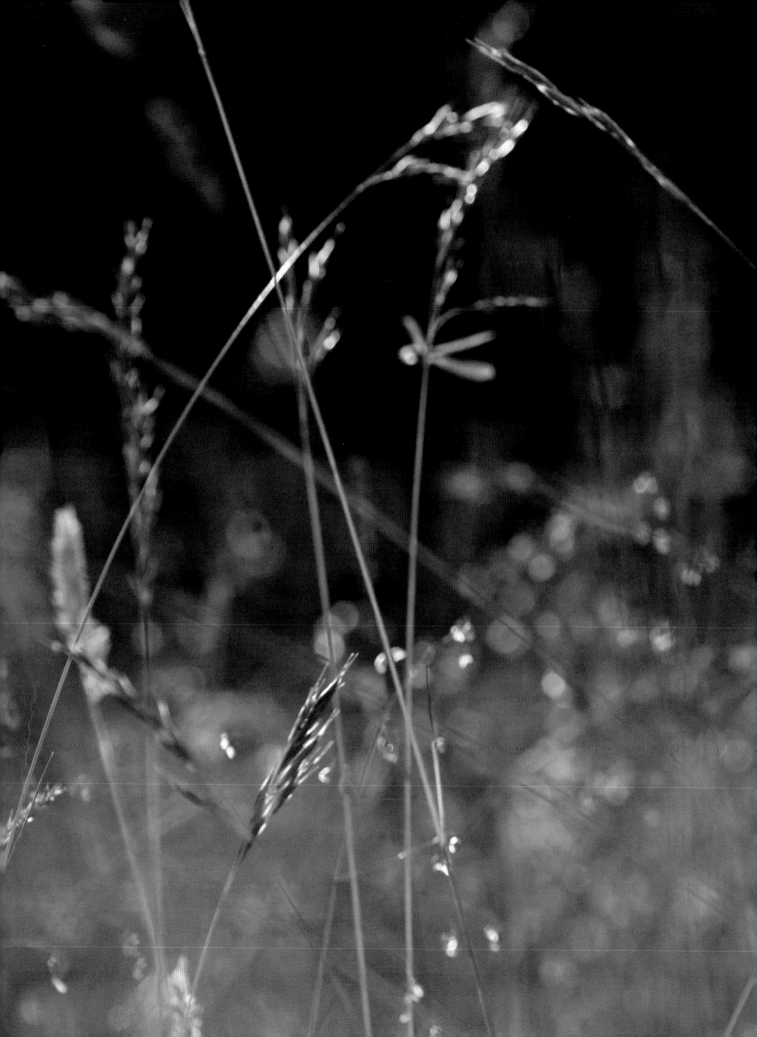

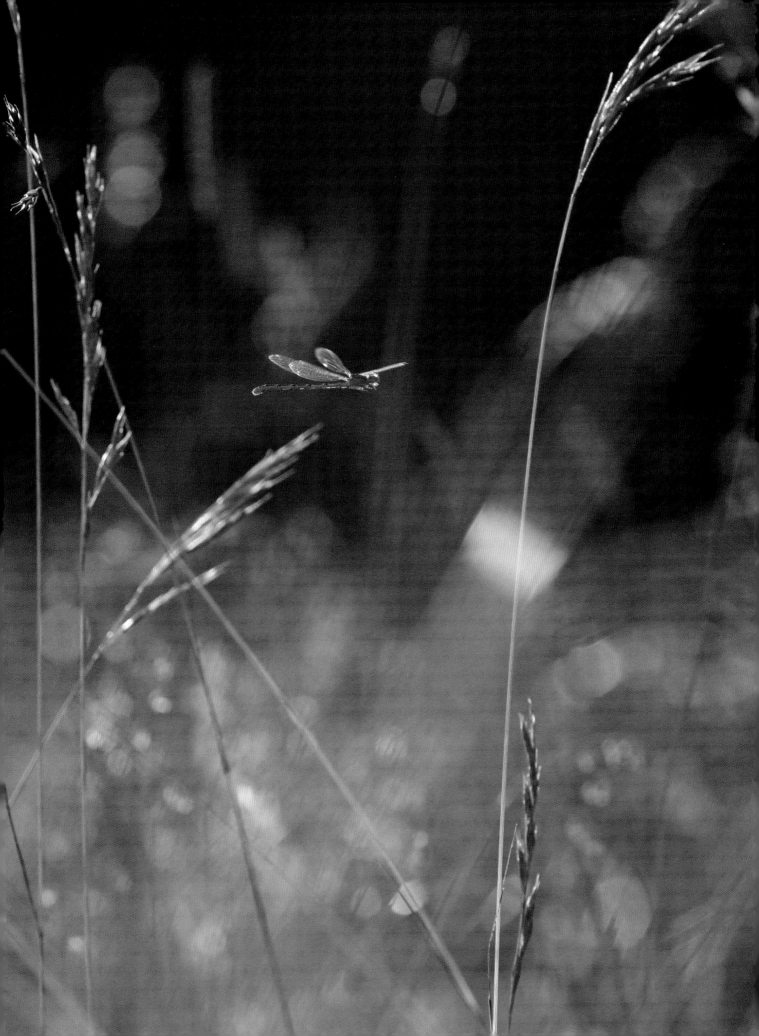

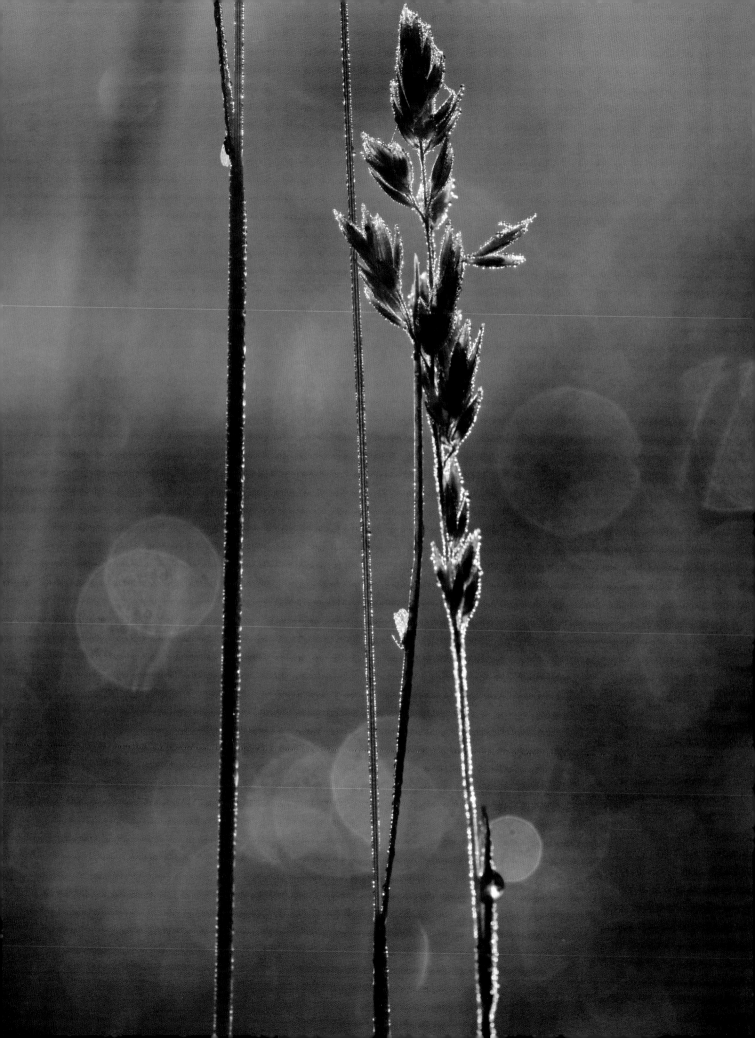

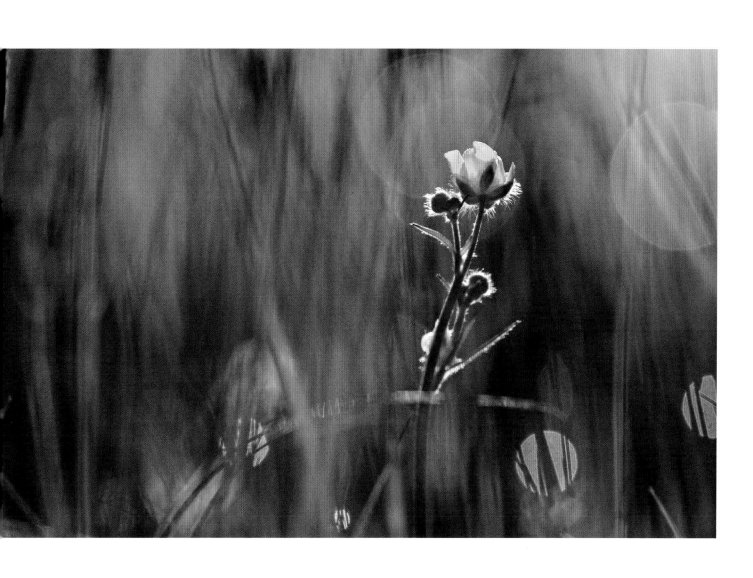

LEFT Cocksfoot (*Dactylis glomerata*)
ABOVE Meadow buttercup (*Ranunculus acris*)

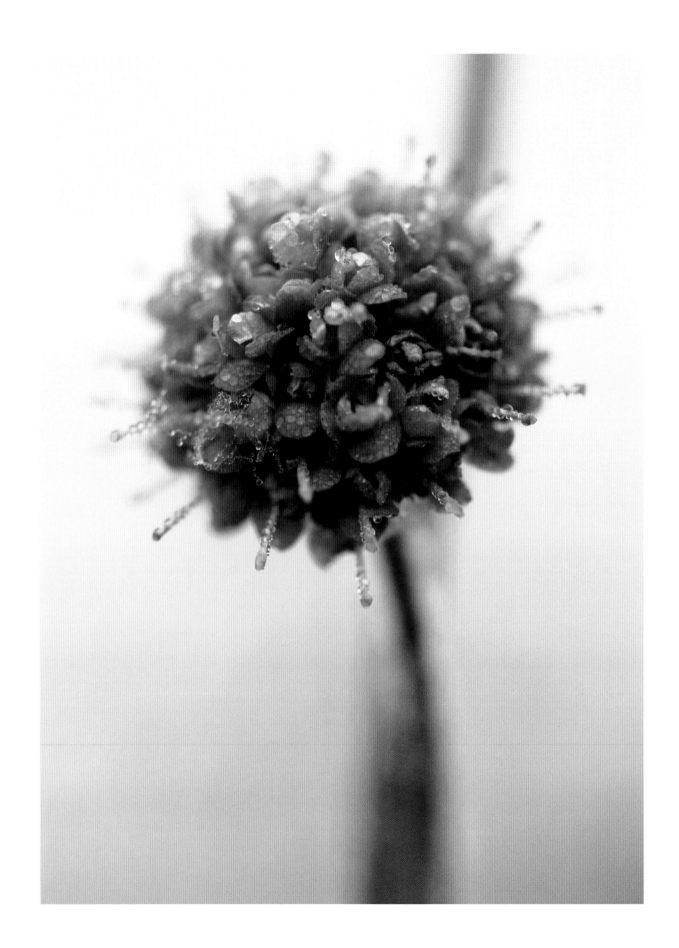

Devil's bit scabious (*Succisa pratensis*)

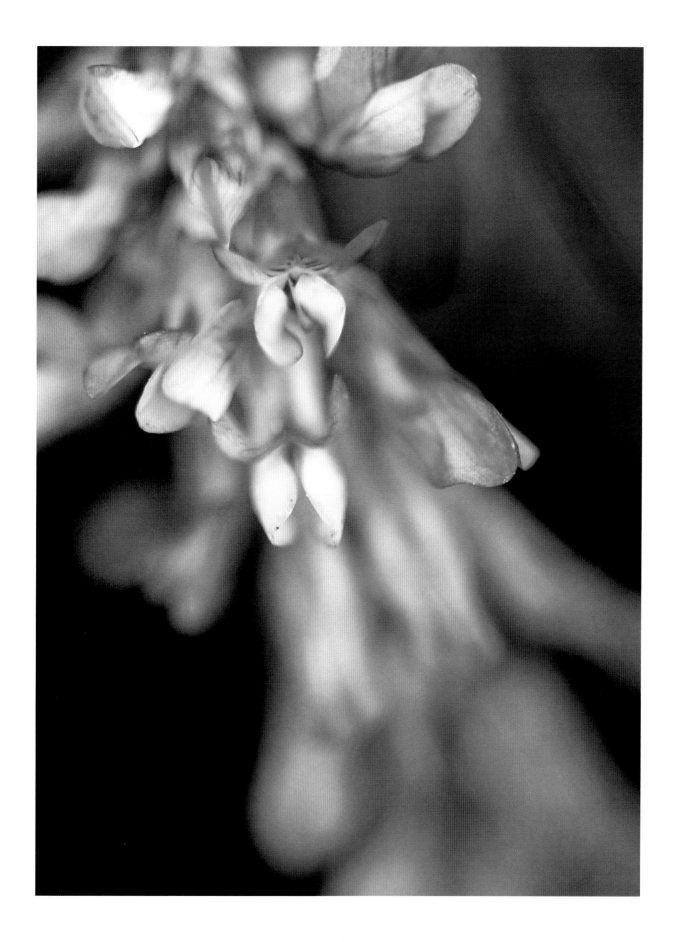

Tufted vetch (*Vicia cracca*)

LEFT Meadowsweet (*Filipendula ulmaria*)
ABOVE Ragged robin (*Lychnis flos-cuculi*)

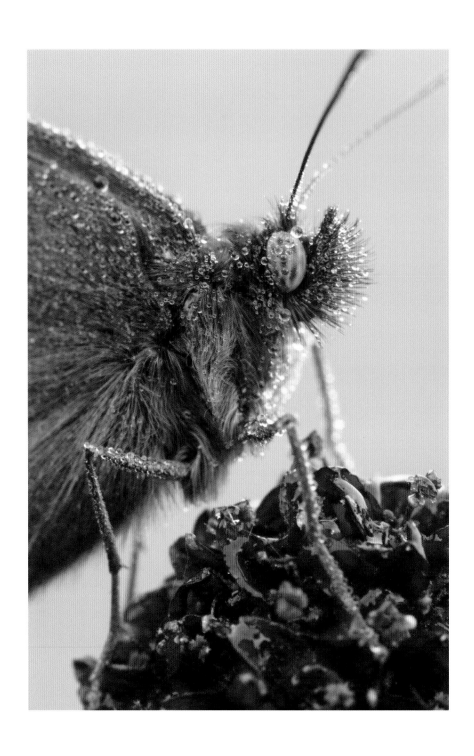

ABOVE Meadow brown (*Maniola jurtina*) on great burnet (*Sanguisorba officinalis*)
RIGHT Knapweed (*Centaurea nigra*)
FOLLOWING PAGES A profusion of common spotted orchids (*Dactylorhiza fuchsii*) and hawkbit (*Leontodon*) species

1. Spring flowers

April. With the soft, oscillating stems of summer gone, memories faded and confused, the meadows are unconcealed. The landscape is hard, its shapes exposed by late frost. The grass is short; thick with crystals of water, the blades are repairing themselves after the damage inflicted by snow, winds, hooves and the dexterous lips of winter. The Belted Galloways have left, leaving cow pats, rutted hollows around water troughs and hair bound to the hawthorn.

The clouds hang low, off white with a strip torn above the horizon. A punch of daybreak orange counters the whitewash. Straggling winter migrants are making their epic bi-annual journey.

But life is pushing outwards. Leaf buds are beginning to break, fringing branches like a dark webbing. The grass and rushes are extending. Standing above them are pale stems, with a crystalline glaze that blends white, green and gold, holding bunches of flowers: thousands of cowslips which, as I lay prone to change my viewpoint, thicken to a carpet. Substantial leaves with undulating surfaces underlie the stems. From these stooping supports hang calyces, green and ribbed, their colour nearly obscured by the ice. The goblet-shaped flower that protrudes from each one, usually a brilliant gold, is pale. Though the appearance of these plants with such a cheery countenance seems to be defiant in such conditions, they are sturdy little things, happy in the lime and moisture of the meadow, and they signal a beginning.

Half a century ago these flowers were still a resource, used in recipes such as cowslip wine. The meadow saw people bent double to collect the flowers. With a gallon of flowers required for each of water, it is no wonder that they declined. Now the strict protection of Clattinger Farm serves them well.

Crossing to the gateway to the next meadow I pause. Half concealed by spreading dog and guelder roses, I scan the field for fox and deer but see none. When I slide the sprung bolt the gate squeaks and groans as its hinges turn. I follow the meadow's boundary. Ditches under run the hedges and will soon flow with water, as will the central fold that splits the field, home to yellow flag iris, reed bunting and canary reed grass.

At the corner I go over a stile. Like the others the next meadow is thin, but it stretches outwards, curving beyond view to left and right. Tall willows form a wall on the left; oak and ash punctuate the hedgerows on the right. And before me lie thousands of flowers. In expansive drifts, these are dark, brooding, with heads like inverted tulips. The petals of deep purple are chequered with white. Gossamer wraps around them, but too thickly; viewed closer it becomes heavy ice crystals, long and encasing. The leaves wind upwards. Rounded with sharp points, they appear suitably serpentine against the scale-like pattern of the

flowers. Their colour is strange, a muted olive with hints of blue. The suffuse purple is punctuated by creams and yellows. The chequered white pattern becomes the slightest impression on these mutations.

It would be easy to argue that the snake's head fritillary is one of the most exotic native species that the UK has to offer. It is certainly a hugely romantic flower, combining grace, drama and just the right amount of pathos in its bowing, rejected-suitor posture. A member of the lily family, it owes the first part of its scientific name, *Fritillaria meleagris*, to *fritillus*, the Latin word for a round dice box that is believed to have been covered in a chequered pattern. Cultivated bulbs are common throughout the UK in gardens, where small patches spring up in shady borders. But these cannot compare to the view of the flowers across such a meadow, when the sun is low and illuminates the thousands of lantern-like heads, distinct at close quarters but from afar a rich purple mirage.

Like the orchids we came to see that first day, the snake's head fritillary is one of those plants that can generate enthusiasm whether you are interested in plants or not. A display of these flowers is so unusual, so breathtaking, that it is hard not to be overcome.

A sight like this was once common in England. The damp conditions of the traditional meadow were ideal for it. Flowering a couple of weeks after the first masses of cowslips, the bulbs multiply, and seeds that form in gourd-like heads further bolster numbers. But the specialized habitat that the plants require is delicate and easily lost. The widespread draining of waterways around farmland, making it more suitable for agriculture, has removed the damp conditions on which this species relies. In addition the regular ploughing of fields for commercial crops destroys the bulbs. There is little chance of the species reestablishing itself outside its few remaining locations, found largely in the Thames Valley area and Suffolk. The snake's head fritillary is now so rare that one meadow complex, the famed North Meadows in nearby Cricklade, managed by Natural England, contains around 80 per cent of the UK's remaining wild population.

The sun is climbing above the willows, silhouetting the upper leaves. Transmitting the light the cord-like crystals casing the flowers and stems begin to soften, the angular crystals becoming round. Pulling apart, they become strings of tiny water droplets. Each forms a lens through which the drooping bodies become brilliant. When aligned with the sun, the drops shine with an intensity that conceals the normally dominant impression of the plants' colour and pattern. The drops are spaced with a regularity not seen in rainfall and seldom by mist. Each fritillary is almost entirely reduced to form.

As I lie close to the ground, the frost beneath my body cools me. The sun heats my hair and pushes its way under the collar of my shirt. The view from here is good. I wonder if I will still be able to see it in twenty-five years' or fifty years' time and what the inevitable changes to this island, in the climate, our demands and our attitudes, will mean for it. In this moment, as insects begin to fly and birds stoop at the stream edges to drink and bathe, it is hard to know.

ABOVE Cowslip (*Primula veris*), in frost
TOP RIGHT Lesser celandine (*Ranunculus ficaria*)

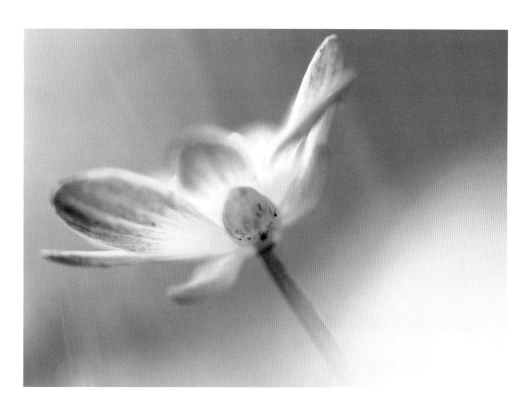
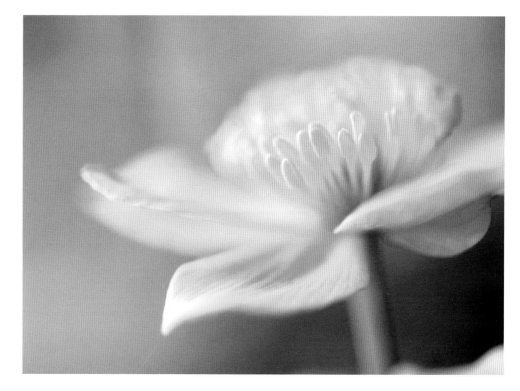

ABOVE Marsh marigold (*Caltha palustris*)
FOLLOWING PAGES Hawthorn (*Crataegus monogyna*)

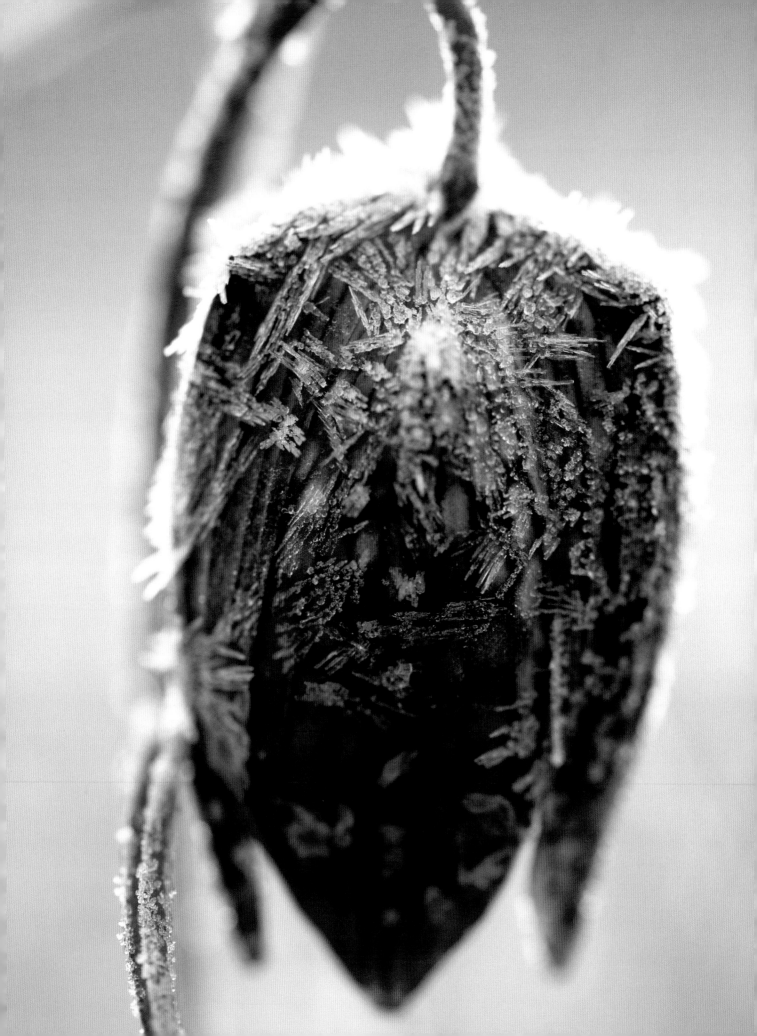

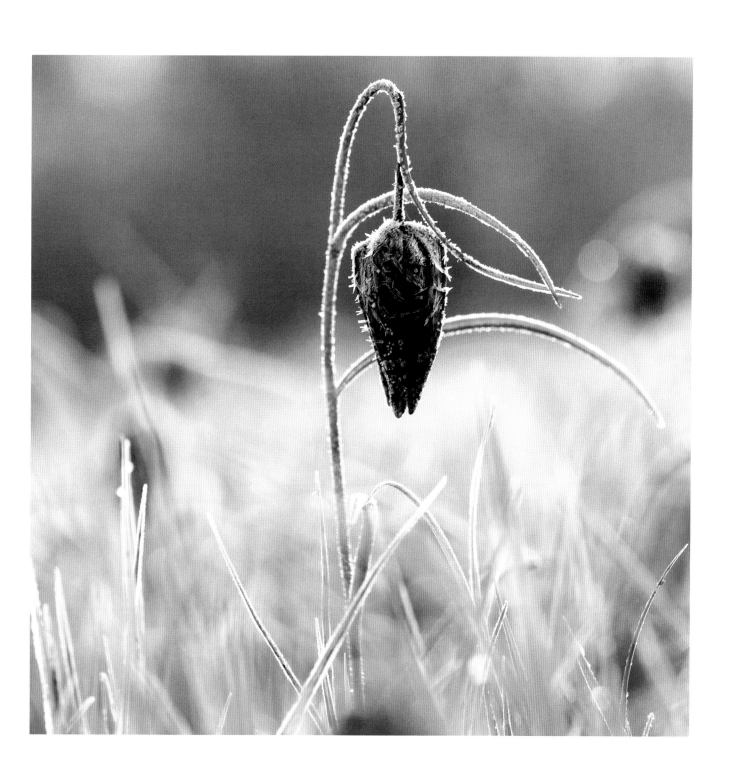

LEFT AND ABOVE Snake's head fritillary (*Fritillaria meleagris*), with frost

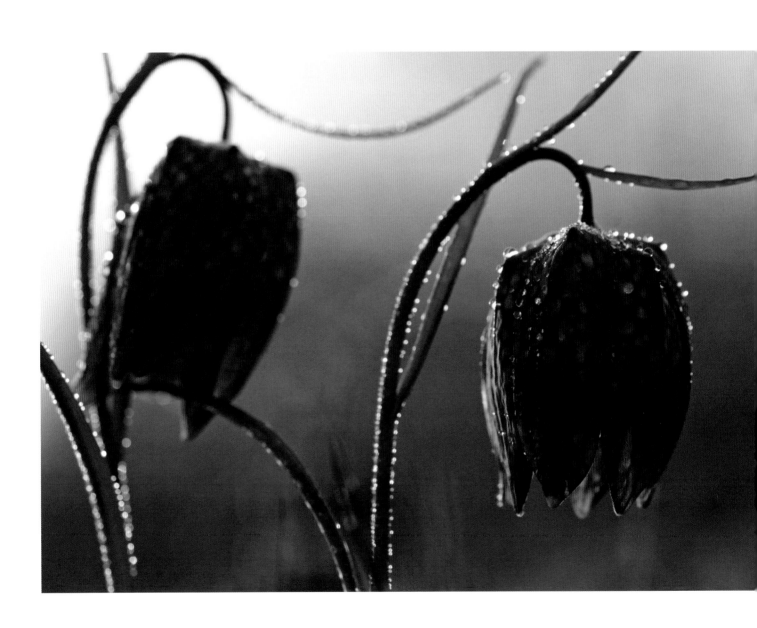

Melting frost covering snake's head fritillaries (*Fritillaria meleagris*)

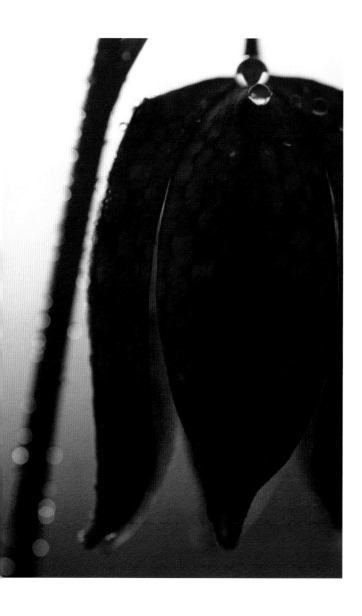

Snake's head fritillary (*Fritillaria meleagris*)

ABOVE AND RIGHT Snake's head fritillary (*Fritillaria meleagris*)

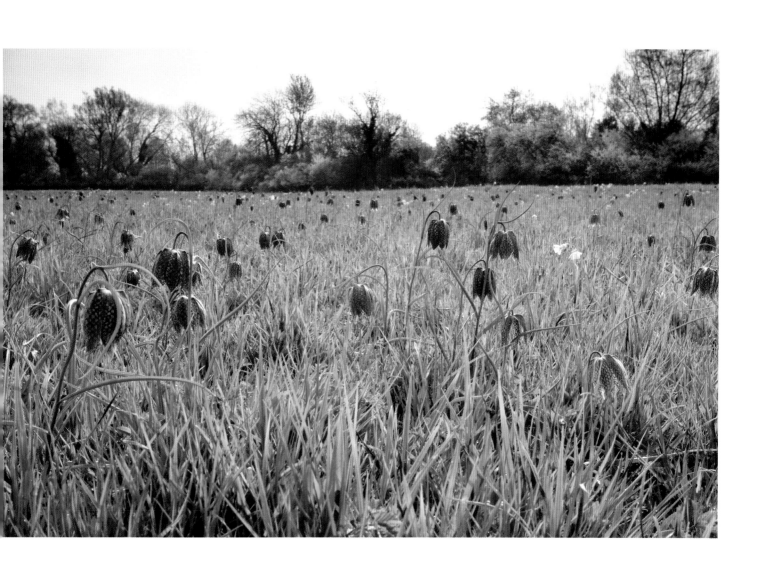

FOLLOWING PAGES The meadows are transformed by drifts of cowslip (*Primula veris*) and snake's head fritillary (*Fritillaria meleagris*)

2. Birds and habitat

As April slips into May, red campion, down-covered willow seed and late bluebells huddled under white-flowering hawthorn catch the eye. The prelude to the white hedgerows was the blackthorn. Their branches were thick with flowers whose white petals made the orange pollen held outwards on anthers appear all the more vibrant; the blossom turns the hedgerows into pale canvasses. Unlike the blackthorn, the hawthorn's leaves emerge first, before the flowers, filling the gaps. The flowers' anthers are a violet red. Looking closer one can see that the occasional flower has an underside tinged with a dark rose-pink that fades to white at its base. The millions of flowers in these towering hedgerows feed countless insects.

The extravagant blooms cannot help but draw attention away from the more subtle plants. One of the most fascinating of these is hidden beneath low blades of grass: a fern, just a few inches high, is unfurling. Its single leaf opens to a hood, revealing a long, ribbed spore-bearing tongue. With the logic of sympathetic magic, its snake-like appearance, suggesting a remedy for bites, earned it the name adder's tongue fern, *Ophioglossum vulgatum*. Its appearance seems all the stranger on the discovery that the roots harbour fungi mycelia, which help to draw nutrients from the humus in the surrounding soil and feed its host. Its genetic make-up is also hard to believe. Its cells contain 512 chromosomes, an astonishing amount compared to our paltry 46. Even this, though, is dwarfed by the tropical netted adder's tongue fern, *Ophioglossum reticulatum*, which boasts 1,260 chromosomes, the highest recorded number in any known species. Classic indicators of the health of lowland meadows, the adder's tongue ferns are at first invisible. But spot the waxy, lime-green leaf of a single one and dozens become apparent. Gathered in groups, they mark their small place in the biological weave. This is often the way: hidden and then at once obvious. Knowledge and timing enable experiences that would otherwise elude those of us who are unaware of our surroundings.

I wait. A few clouds, loose in long trails, break up the sky. As the last slip of sun pressed the horizon they turned deep purple and then soft pink. Now grey, they are backed by light that still emanates from the horizon. The birds are

singing; their complex voices blend. My eyes, struggling against the darkness, scan upwards from the field's fading silhouettes. The horizon carries a strip of celandine yellow. The heat of this colour contrasts with the thin blue above and the much thicker layer of luxuriant purple that overhangs them both. The song of the birds weakens until only that of one species remains.

This is a small olive-brown bird, sitting among the dense blackthorn – home to dozens of birds and a corridor for many more. Hidden from view, its apparent agoraphobia at odds with the fact that it has recently migrated from Africa, the nightingale makes up for its physical absence with an extroverted night-time melody. Long ever-changing clicks, chaks, cheeps and almost mechanical whistles distinguish its endlessly varying song. Every year these birds return, ready to breed in the same location, to sing the final verse in the evening chorus.

Like so many species, though, on returning to their annual homes they frequently find their habitat removed. The heavy, spine-covered blackthorn thickets and hedges they rely on are disappearing. Without the habitat they rely on for food and protection, the birds – members of the thrush family – are lost. Between 1967 and 2007 their numbers fell by 91 per cent in the UK. Between 1980 and 2005 they declined by 63 per cent across Europe. The night is becoming too quiet.

The bird population here is constantly shifting. Year-round British residents both inhabit and pass through the meadows. A buzzard uses the outcrop of a dead oak branch. Gangs of pink-blushed, long-tailed tits roll through the interlocking twigs of the trees and hedgerows, stripping them of insects. Iridescent magpies watch from chaotic nests and herons, necks folded into fat chins, fly with slow beats of their vast looped wings. Together they watch the influx and exit of seasonal migrants.

On another late spring day a movement to my right made me freeze. A female chaffinch was watching me from a low branch in the hedge. There was something in her movement, her position and the fact that she hadn't moved. Moving slowly away with as much nonchalance as I could muster, I sat looking away from her. She disappeared and returned a couple of minutes later, her beak filled with strands of moss. Rigid, I watched as she slid behind the branch into its fork.

Standing on an unseen platform, she carefully placed the bedding beneath her and then, inclining her breast, pressed it into place.

When she flew across the field again, and after I had convinced myself that her mate was nowhere around, I allowed myself a few seconds at the nest. Sandwiched in the fold, wound to follow the shape of the branch, it was strong, small and near invisible. The inside was conical, soft with moss and down. The nest's surface imitated the lichen that covered the black bark, its edges indiscernible.

After sitting back down I watched as the chaffinch returned several times, assiduous in her task. When she had gone again I slipped away. I thought about returning to photograph her, this small creature that, for the moment, was succeeding in a life filled with risk; but the thought of the potential desertion of eggs or chicks and the wasted time and energy I might cause immediately made me abandon the idea. Nevertheless, a few days later I walked past and told myself I would steal a glance. I knew the hedgerow; I thought I even knew which sprawling grey willow the nest was in and where the branch was. My eye searched over the branches and I kept walking until I was sure I had passed it, but no nest. I didn't worry: I was sure it was still there. I felt comforted by how hard it was to find.

The bird was one of our year-long chaffinches, whose population is boosted by incomers in autumn and winter. Migrants such as the cuckoos in spring, with their steel backs and camouflaged bellies, whose light call belies their mischievous task of finding a surrogate parent for their eggs, or the hobbies who circle the summer skies hunting for dragonflies seem to become our own, birds we think of as typically 'British'. Influxes of winter blackbirds swell the normal year-round population of half a million breeding pairs to a total of 10–15 million individuals. Bounding over the field surfaces, they pick at grubs and worms, occasionally flying upwards with an explosive chattering. Other members of the thrush family arrive in autumn. Fieldfares and redwings are classic farmland birds. They tumble systematically through the hedgerows, making raucous calls.

As they hop between branches and fly close to the hedgetops their target is berries. The hawthorn and blackthorn, so profuse in flowering, are now equally well covered in red and midnight-blue fruits. The haws are used in syrups, wine and jellies; the sloes, the blackthorn's berries, are used to flavour that winter favourite sloe gin.

Whether birds are seasonal visitors or permanent residents, a landscape that provides protection and food throughout the seasons is fundamental to them all. Changes to modern agriculture have removed many of the essential elements of this. Large-scale mechanization has led to larger field sizes and the removal of hedgerows. The timings of crop planting and harvest have changed, becoming more rapid. Drainage too has altered the landscape. Plant species diversity has decreased with crops and fertilized silage fields replacing traditional hay meadows and monoculture crops now spreading for thousands of hectares. Fungicides, herbicides and pesticides have further reduced diversity.

These conditions have led to the loss of nest sites, areas to forage, insect levels and seed for specialist feeders. The widespread habitat losses only serve to isolate remaining populations. It is not surprising, then, that in the last half-century farmland birds have been among the most greatly affected. The Pan-European Common Bird Monitoring Scheme pooled information collected across 20 countries and found that between 1980 and 2005 the populations of farmland birds was reduced by 44 per cent. In the last 40 years the UK has seen the decline of corn bunting by 86 per cent, grey partridge by 87 per cent, skylark by 59 per cent and tree sparrows by 97 per cent. Nor is it surprising that we are seeing declines in the species that rely upon our grasslands: iconic birds such as the great bustard occur in very few locations in the UK.

It is easy to forget, when faced with somewhere as special as the traditional hay meadow, that in the near past it was not an unusual sight. The rare diversity we marvel at was common less than a century ago. Sadly today Clattinger Farm and other remaining protected meadowland sites have become biological islands with little chance of extending their shores.

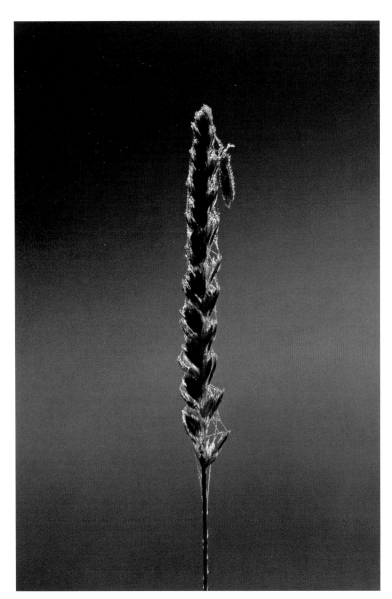

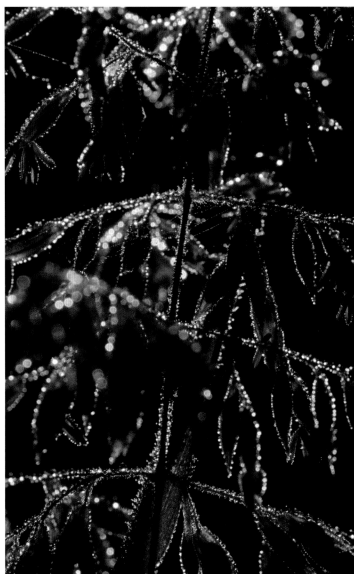

LEFT Crested dog's tail (*Cynosurus cristatus*)
RIGHT Yorkshire fog (*Holcus lanatus*)

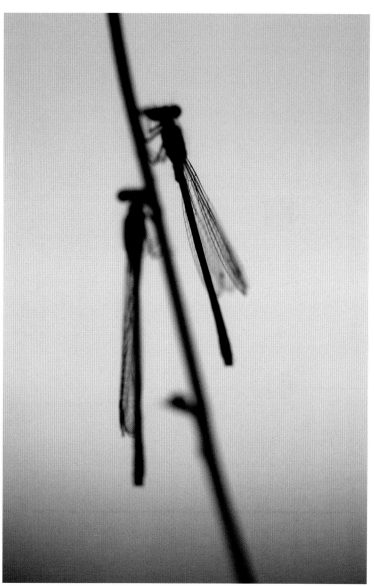

LEFT Devil's bit scabious (*Succisa pratensis*)
RIGHT Common damselfly (*Enallagma cyathigerum*)

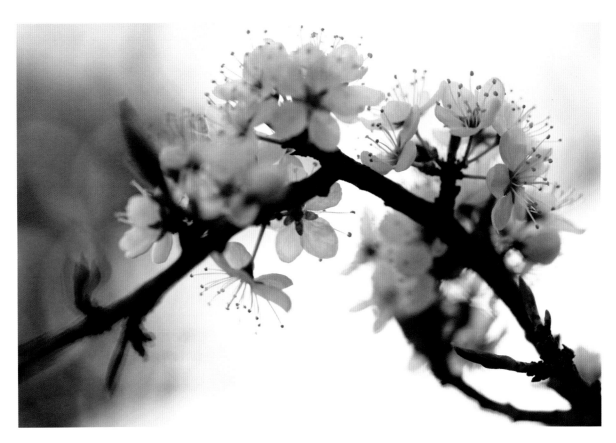

TOP AND BOTTOM Blackthorn (*Prunus spinosa*)

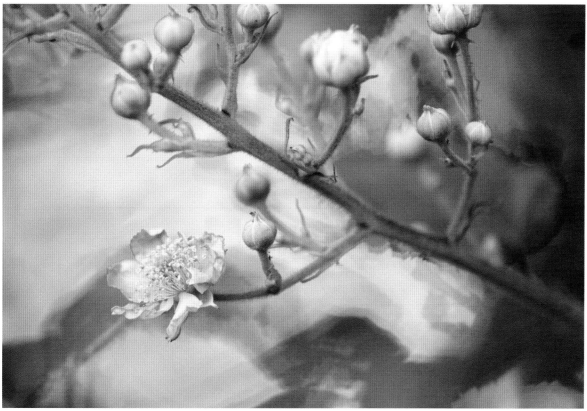

TOP Hawthorn (*Crataegus monogyna*)
BOTTOM Blackberry (*Rubus fruticosus*), in flower

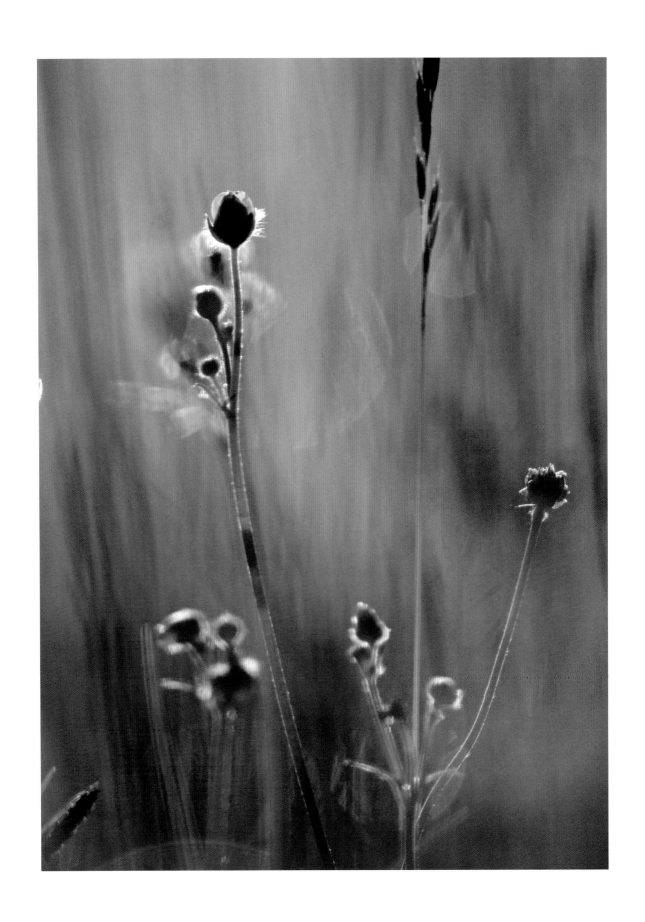

Meadow buttercup (*Ranunculus acris*)

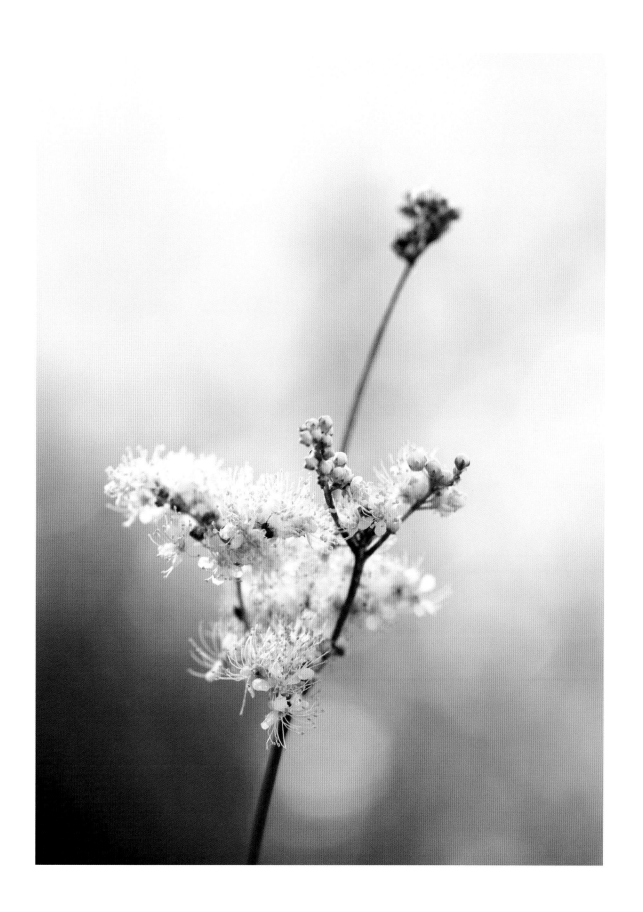

Meadowsweet (*Filipendula ulmaria*)

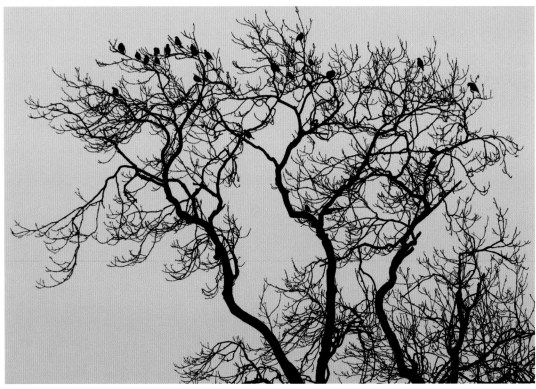

TOP Redwing (*Turdus iliacus*) in willow (*Salix* species)
BOTTOM Roosting redwings (*Turdus iliacus*)
RIGHT Canary reed grass *(Phalaris arundinacea)*

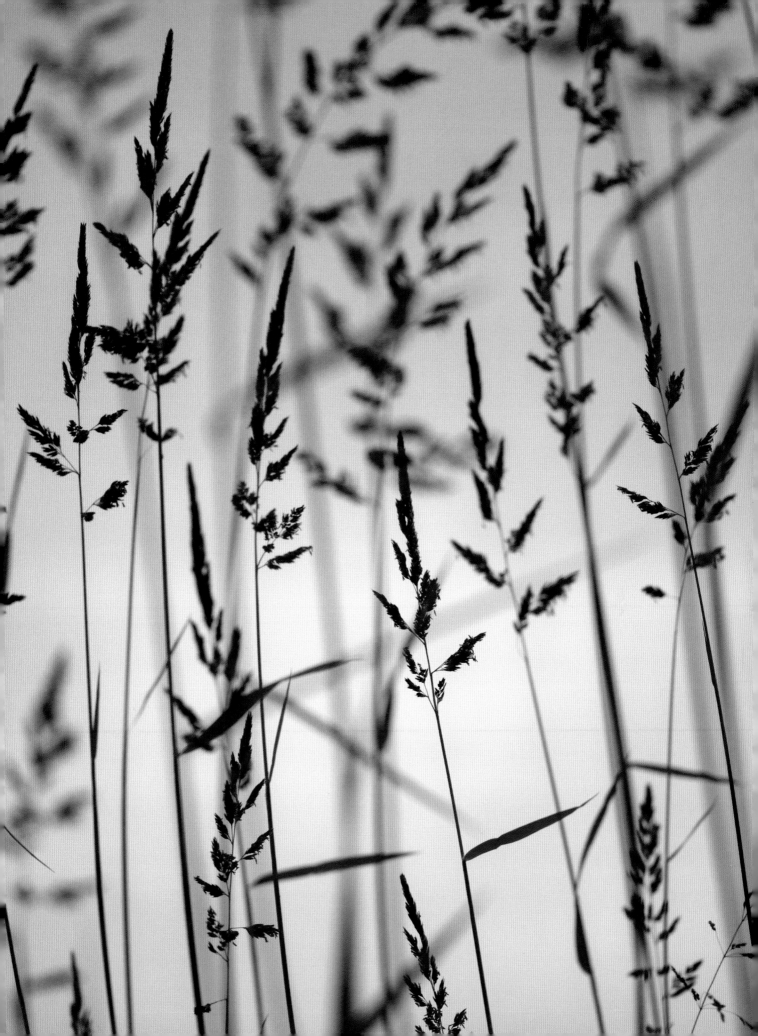

Dog rose (*Rosa canina*)

Milkwort (*Polygala vulgaris*)

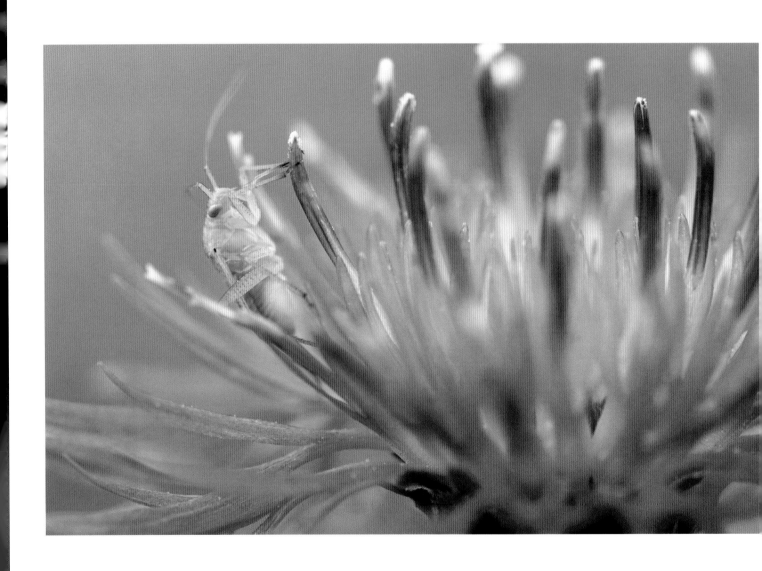

ABOVE Potato caspid (*Closterotomus norwegicus*) in common knapweed (*Centaurea nigra*)
RIGHT Sunset in the meadows with yellow bedstraw (*Galium verum*),
common knapweed (*Centaurea nigra*) and hawkbit (*Leontodon* species)

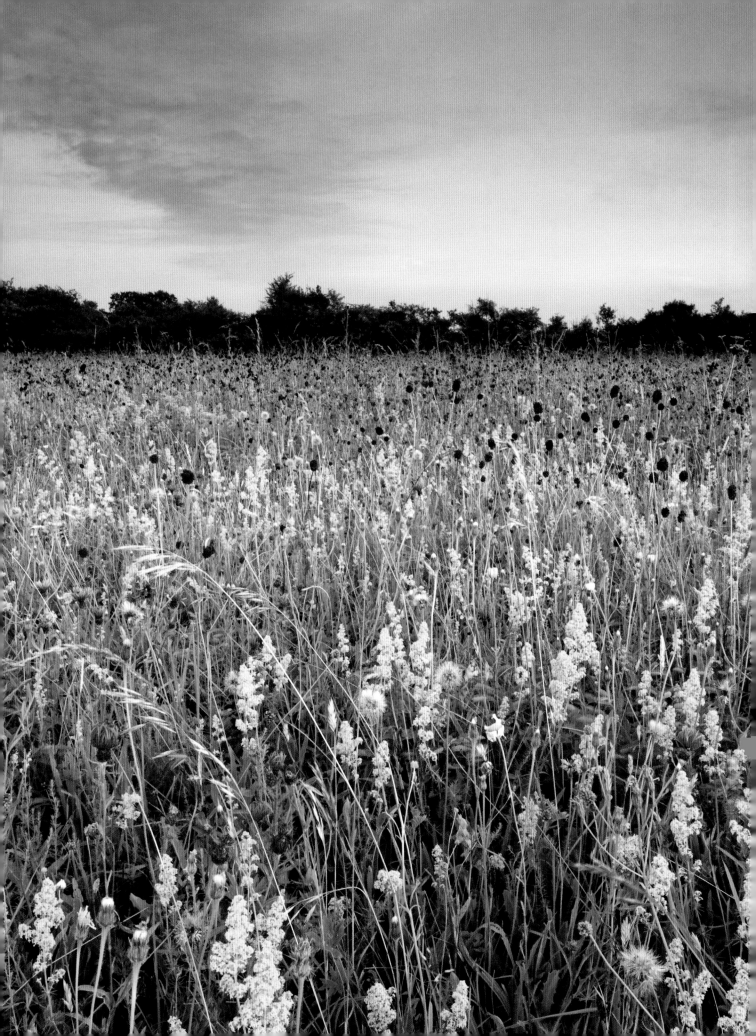

3. Orchids

The dense, maroon-tinged purple tops loosen, opening out into shapes like primitive figures, the white bodies dashed and hooded with purple. The tiers of flowers are increasingly separated further down the bright green stem until the lower flowers hang isolated. The characteristic dark top of unopened blossoms, contrasting with the mixture of white and purple extending below, provides this flower, *Neotinea ustulata*, with its common name of the burnt tip orchid. The lightly scored leaves hold the stem close to its base. Broadening, they curve inwards, forming shallow gutters that hide among the leaves of plantains and Jack-go-to-bed-at-noon. Their indifferent shape and colouring seem to be little more than a neutral base for the exuberant flower spike above them.

The burnt tip orchid is a rarity, limited to around seventy-five sites across the UK. Yet it remains the official flower of Wiltshire. One easy explanation for this is the density of the calcareous grasslands that this county contains and upon which this species relies. But there is something more. From the rainforest to the mountains, between storms and rarified air, orchids are widely spread and – not just this individual species but also as a group – hold a fascination across the world. Their stems and leaves that are often thick, heavy and not invested with great beauty themselves, but the flowers are fascinating in form and pattern, and have a visceral appeal, vulgar in their complexity and flaunted beauty yet utterly captivating. Other plant families balance that fine combination of subtlety and structural ingenuity, and even rarity and sporadic appearance, but the orchids are firmly cemented as a favourite for many. One of Britain's orchid species cannot fail to impress, whether you are a dedicated fan of orchids or have no interest in plants whatsoever.

It is early June. That conical, deep purple head of the burnt tip is breaking apart, the last figures stretching outwards. Another species of orchid flowers near by, beneath arbours of grasses: crested dog's tail, Yorkshire fog, creeping bent, cocksfoot and red fescue, their seed heads bursting outwards, pollen drifting as vapour. A short stem with thin pointed leaves appears to have attracted half a dozen insects. Their abdomens are a rich, near-black chocolate. Fine ginger-russet hair covers them, highlighting their edges. Patterns differentiate each plant. Sulphur splatters, a violet band and a cinnamon shield decorate its back. Three wings twist outwards, suffused with pinks,

purples or lilac. They curve around central green veins, rounding to soft points. Arching from the head, back over the body, is a striated projection, reminiscent of a duck's head. Two pollen sacs like gilded testes hang from its crop. Together these features, strange when individually isolated, form an instantly recognizable impression of a bee.

And it is exactly that: an impression. The bee orchid, for that is the plant, is small but so bizarre in its mimicry that it has a dominant appeal. Even its name, *Ophrys apifera*, draws on its appearance, *apifera* translating as 'bee-like' or 'bearing bees'. The accuracy of its depiction is believed to be an evolutionary step towards attracting pollinators, encouraging male bees to try to mate with the seductive bloom. The pollen sacs attach to the bees' backs as they try to force themselves on this capricious beauty and are passed on to the next flower the bees visit. Although bee orchids are now largely self-pollinating, there are related species such as the Mediterranean bumble bee orchid, *Ophrys bombyliflora*, whose appearance, as well as the scent that replicates female bees, ensures that the plants are still largely pollinated by mistaken insects.

The mystery of the bee orchid's structure is multiplied and a further caprice added by its consistent failure to flower in the same location each year. These perennial plants survive quietly, the tuberous roots and leaves bunkering down for years unless the ground is disturbed or ploughed, destroying them. Then suddenly a flower spike with the bee accoutrements appears. Whole patches, dozens of spikes, can appear one year and twelve months later that area is apparently bare while another, previously empty, is rich.

This strange plant has an even stranger twist. Also found at Clattinger Farm, though largely restricted to the West Country, is a variety of *Ophrys apifera*, a mutation. *O. a. trolli* is so distinct that it was once considered a different species. The swollen back of the bee orchid is narrowed, twisted into a sharp icicle of a point. The sulphur splashes are more dominant and the ferrous orange now intersects them. Even the petals are sharper, more aggressive, falcon-like. Observing such a specimen, I was struck by its vigour; twice the height of the bee orchids that surrounded it, it exuded strength. The stem was covered in flowers, their shape, as with the bee orchid, a perfect representation of the plant's common name, the wasp orchid. My heart beat fast, my breath shortened by the

compression of kneeling to the flower's own height, at the sight of something so rare, so transient – a sight that few people have each year.

The burnt tip, bee and wasp orchids are not the first orchids to appear each year. From the middle of April green winged orchids populate the fields. Their blousy flowers, held separately in rough cylinders, follow the grooves that mark the wettest channels of the meadows. Appearing before the thick growth of summer, they add lush pinks and purples that blend with the olives of the surrounding vegetation. The name is at first confusing; the rich purple of the flower and a stripe of white down the centre of its lip ornamented with spotting provides no clue. At first glance even the bonnet that overhangs the lip does not make its identity apparent. However, look at one of the pale pink forms and it is possible to distinguish the green lines that skirt this feature.

Green winged orchids are joined in a few weeks by the twayblade. Like the burnt tip, the flowers of this orchid are reminiscent of dolls or effigies with pinned backs held outwards. But instead of the chocolate reds and white the inflorescences are a bright lime green, shiny and waxy. Long and tapering, they are at first invisible, but hundreds appear once you recognize that citrus gloss green.

Mid-May marks a floral explosion. Now the early marsh and southern marsh orchids appear. Dense with flowers, their stems are stocky, branch-like, projecting upwards. Broad leathery leaves form sheaths around them. Each flower wears cartoon ears. The petals are thick and – as can be seen when viewed with a lens – dimpled.

The meadows become carpets of flowers as the marsh orchid's near relation, the common spotted orchid, begins to reach its peak. Thousands pale the field surface, white mixed with pinks, purples and reds. Across the meadow, among the buttercups, pepper saxifrage, countless grasses, rushes, plantains and knapweeds, they send their conical flower spikes skywards. The complex flowers, like hooded ball dresses, with sepals reminiscent of shawls spinning outwards, vary from dark purple, through delicate pink to pure white. Robust hybrids – crosses with the early marsh and southern marsh orchids that preceded them – stand twice as tall, gangly above their neighbours. The flowers crowd around the stems, forming a flower spike that is like a pale candle. The rosette leaves are marked with intense violet splashes. The common spotteds hide the twayblade, burnt tip, bee and wasp in their masses. So profuse is the display that it is simple to think of these plants as common – an easy mistake for so many species that are found here in abundance.

Of course this is understandable; everything here grows so well and apart from minor but sympathetic management it looks after itself. But it is a misconception. These species were once widespread. They thrive, as they had to for thousands of years without any conservation, by taking the niche that they evolved to fill. And that was the once-extensive grasslands. Perennials such as orchids can live long lives and spread in a habitat where they have the opportunity to become established. However, turn the soil and drain the land and you are left with a landscape that may be similar in its apparent geography but as a habitat is transformed. In the heavily managed agriculture of today the balance has gone for many of the species that happily prosper in the hay meadows, including the orchids.

The petals of the orchids become like crêpe paper, dry, wrinkled and crushed. When they fall, the worms mix them into the soil, turning and breaking them. Fungi mycelia run through the layers, consuming them and breaking them down into humus that feeds the surrounding plants.

The seed cases swell. The bee orchid's pods are distended, marked with lines that deepen as they mature. The common spotted, southern and early marsh orchids are covered in ovate capsules, ridged along their lengths. The green winged orchids are already reduced to khaki sticks, their seeds spilling. With this seed dispersal and the division of their tuberous roots it is no surprise that they maintain their numbers.

However, even here I have seen only a handful of burnt tips and a single wasp orchid, each in only one of the three years of visiting. The wasp, a localized mutation, is understandably unusual. The burnt tip has more potential to travel.

Once again we return to the issue of the population being isolated. Without new sites for the orchids to colonize and the infrastructure with which to reach them it is hard not to visualize the meadows as islands, with the sea lapping ever closer around them. Similarly that isolation prevents a new mix of genetics from reaching them and helping to reduce the risks of inbreeding and the susceptibility to disease and pests that inbreeding creates.

All the plants here – not just the orchids – do something to you when you take the time to stop and look at them. The aesthetic appreciation of their structural ingenuity, and the patterns drawn and inflated outwards into the most implausible shapes, is only the most superficial recognition of their importance to the planet. Yet for many of us this is enough to persuade us that they warrant conservation, even before we consider their relationships with insects, birds and mammals, including us.

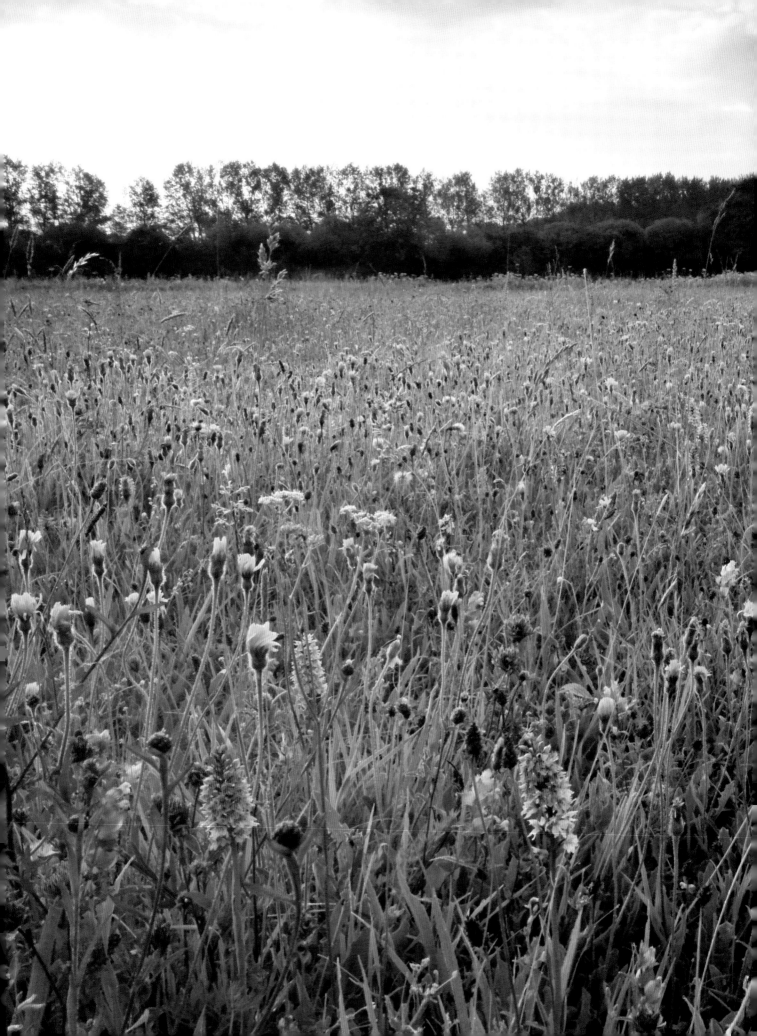

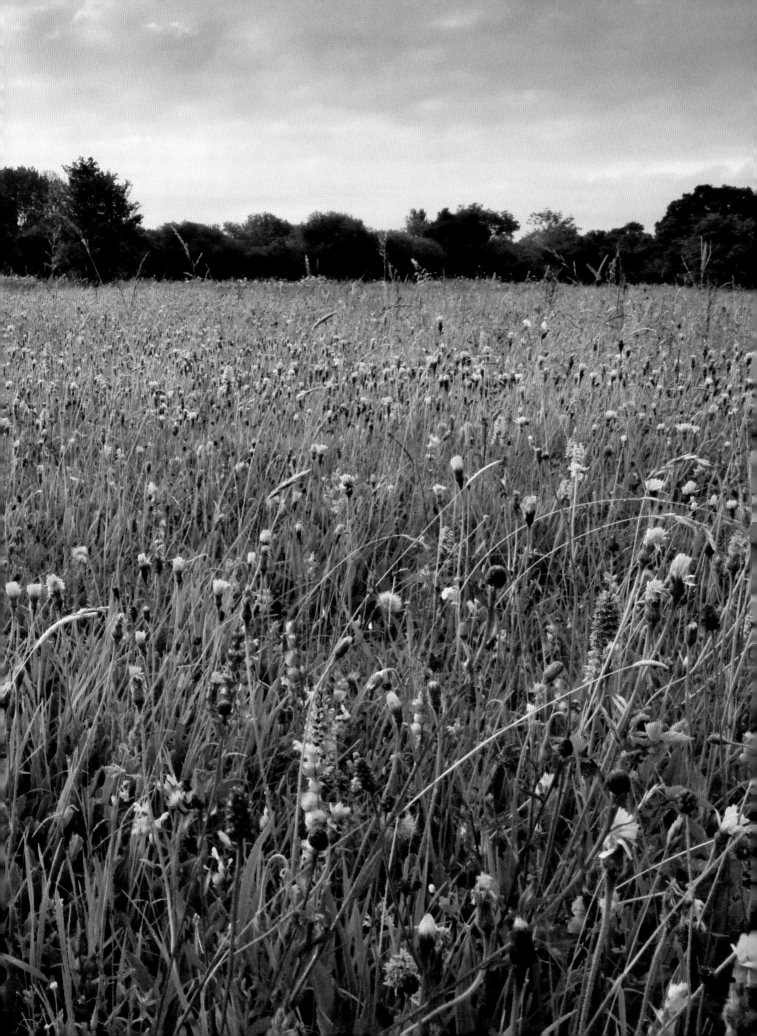

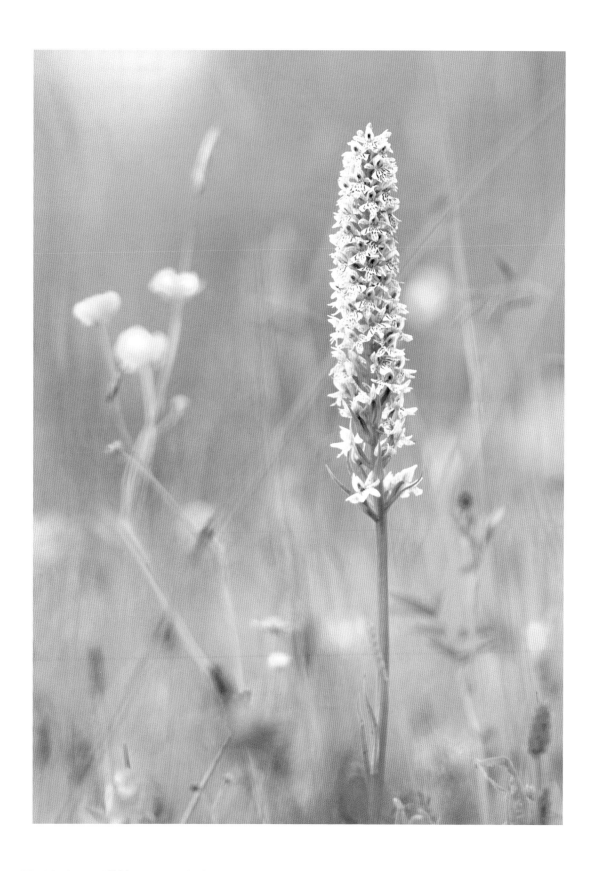

PREVIOUS PAGES With grass much shorter than many of us are used to, the meadows are dominated by flowers
LEFT Burnt tip orchid (*Neotinea ustulata*)
ABOVE Common spotted orchid hybrid (*Dactylorhiza fuchsii*)

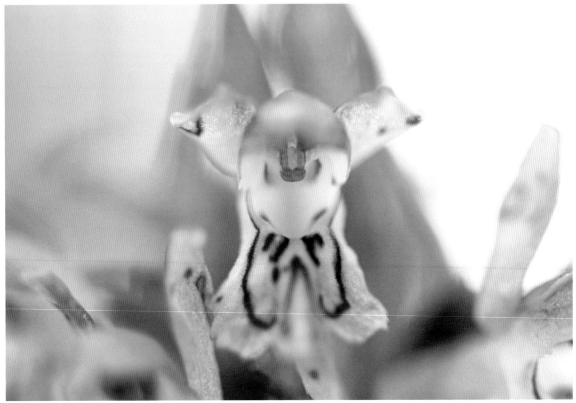

TOP AND RIGHT Bee orchid (*Ophrys apifera*)
BOTTOM Southern marsh orchid (*Dactylorhiza praetermissa*)
FOLLOWING PAGES Common spotted orchid (*Dactylorhiza fuchsii*)

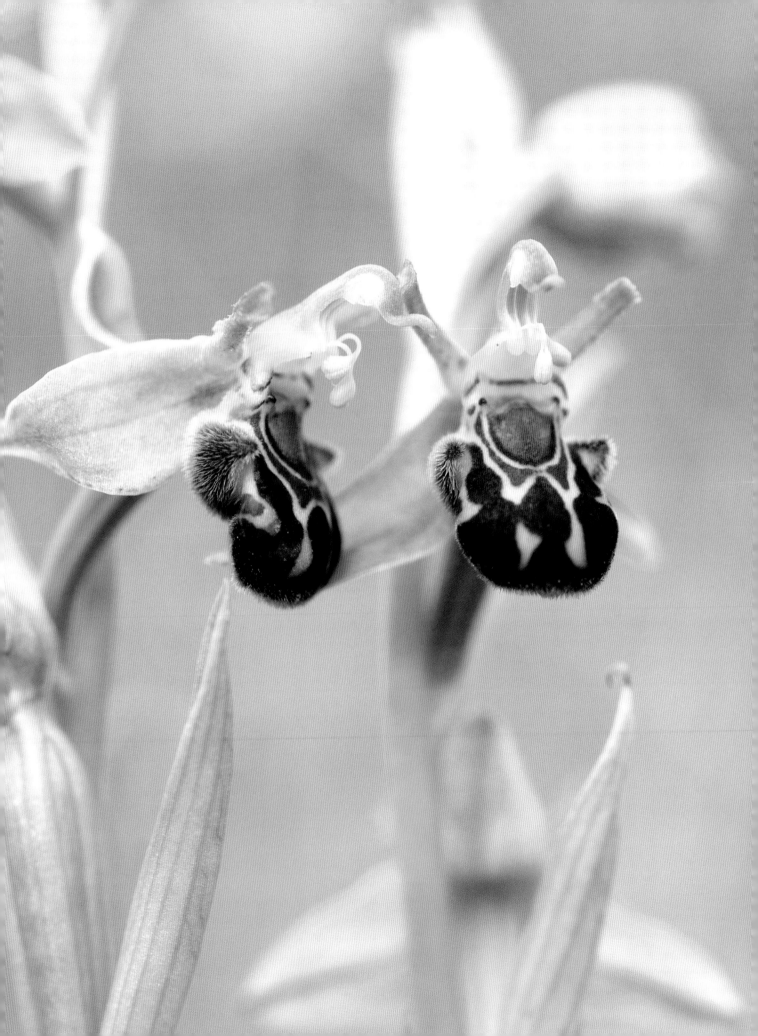

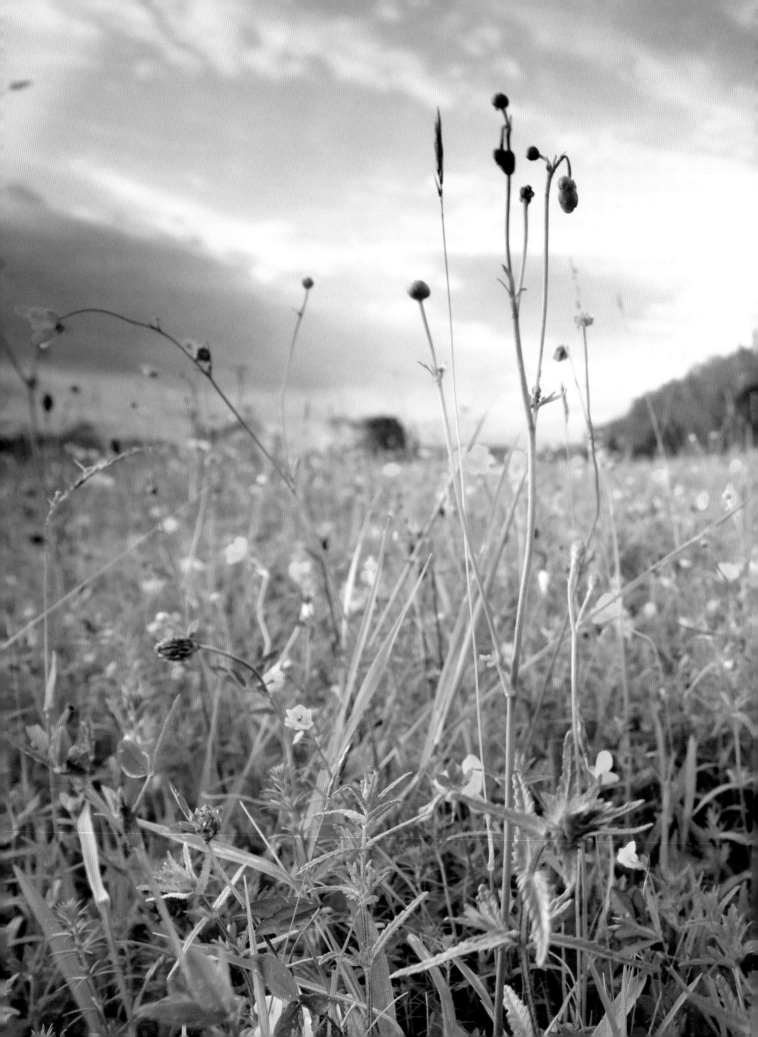

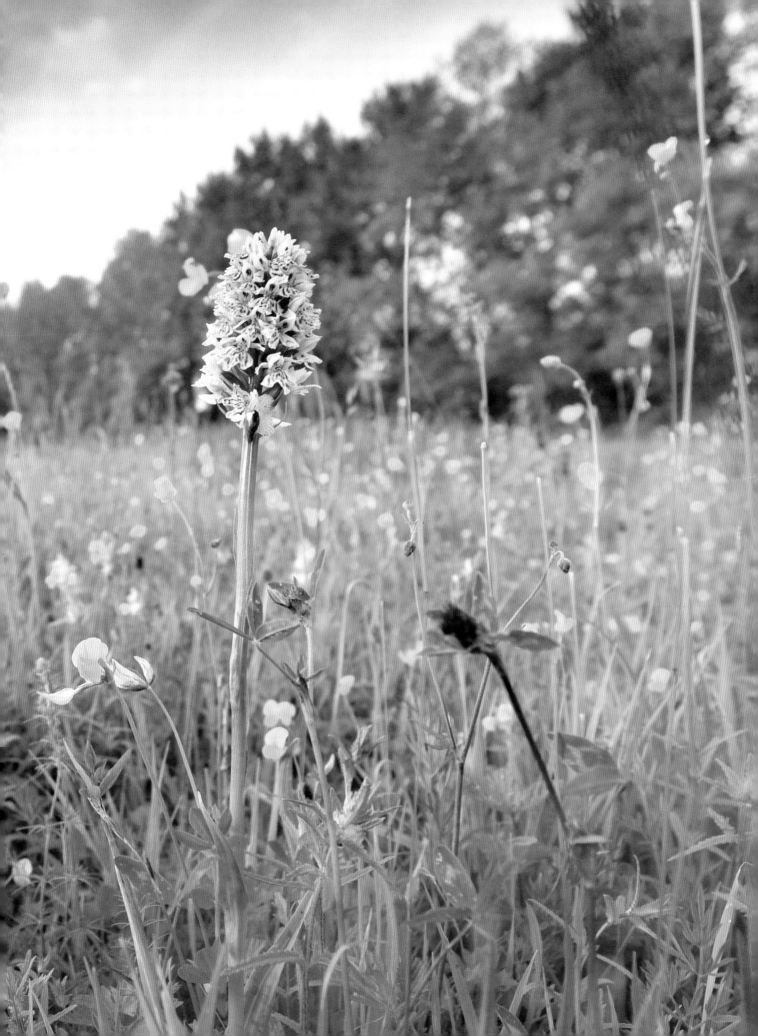

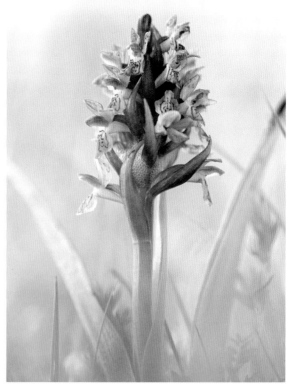
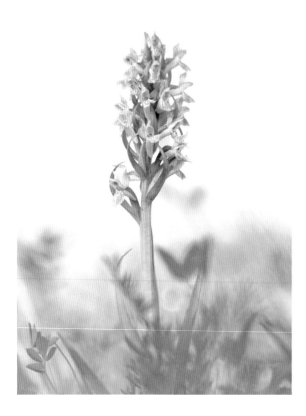
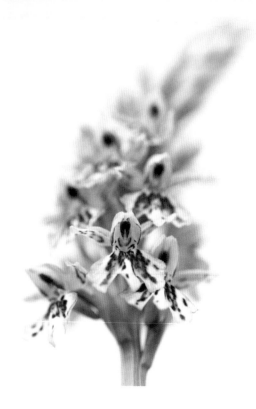

TOP LEFT AND RIGHT Early marsh orchid (*Dactylorhiza incarnata*)
BOTTOM LEFT Southern marsh orchid (*Dactylorhiza praetermissa*)
BOTTOM RIGHT Common spotted orchid (*Dactylorhiza fuchsii*)

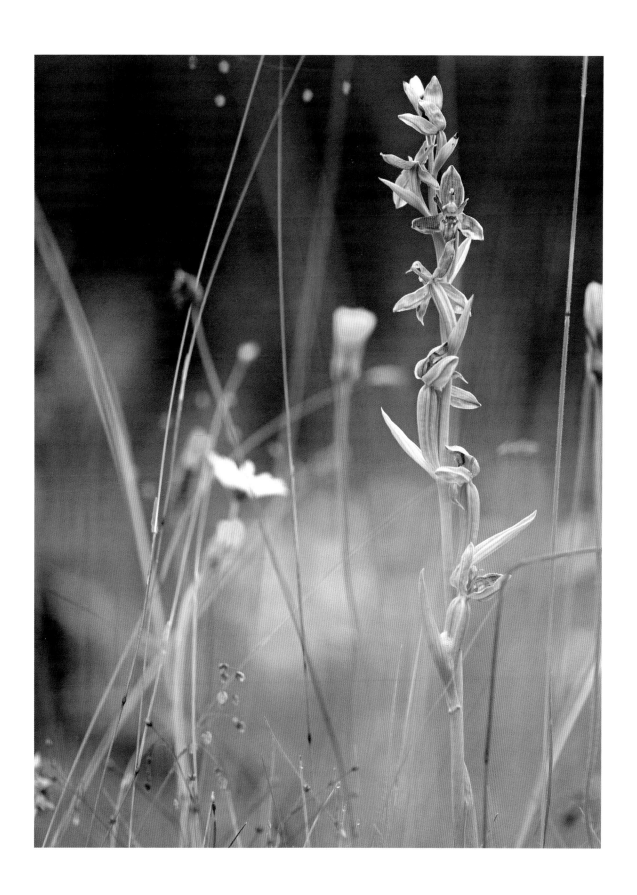

Wasp orchid (*Ophrys apifera trollii*)

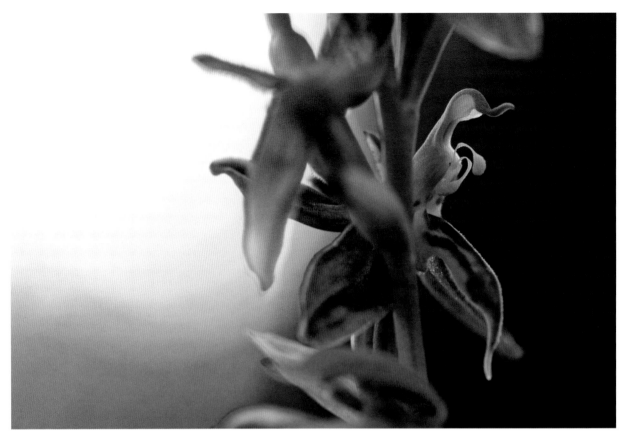

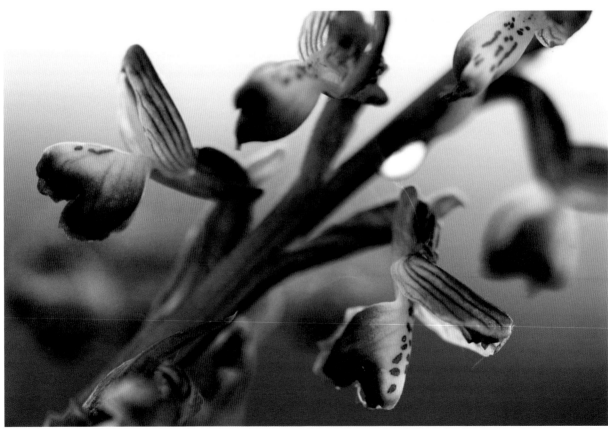

TOP Wasp orchid (*Ophrys apifera trollii*)
BOTTOM Green winged orchid (*Anacamptis morio*)

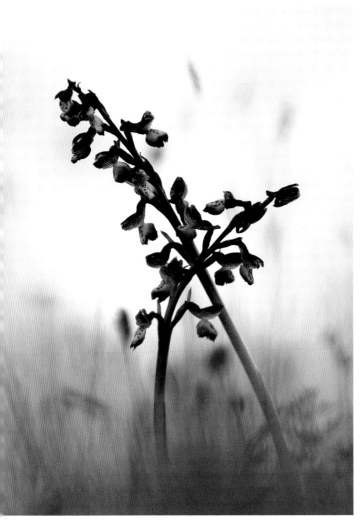
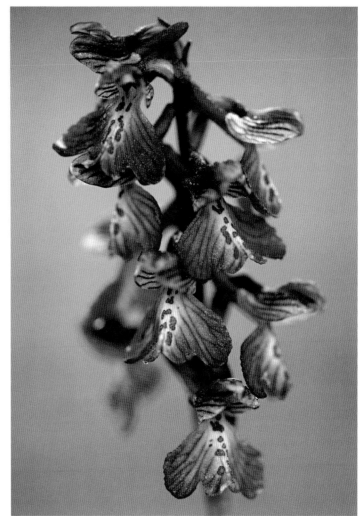

LEFT AND RIGHT Green winged orchid (*Anacamptis morio*)
FOLLOWING PAGES Morning mist over the meadows

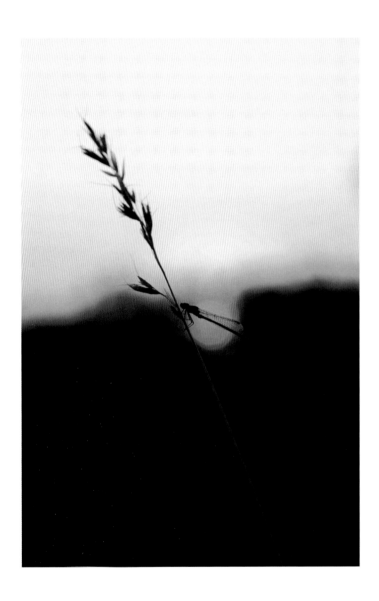
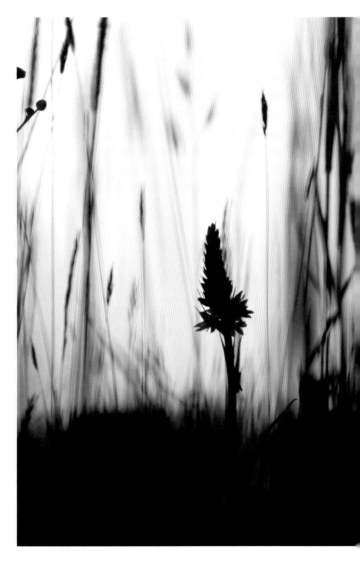

ABOVE LEFT Common blue damselfly (*Enallagma cyathigerum*)
ABOVE RIGHT Common spotted orchid (*Dactylorhiza fuchsii*)
RIGHT Tall fescue (*Festuca arundinacea*)

4. Invertebrates

Guelder rose flowers face outwards like discuses on pliable stems. The toothed edges of the leaves, each divided with three lobes like a gull's foot, curl slightly away from the light, raising the broader plane of their surface in an arch that leads away from three main veins. Their matt surfaces absorb the sunlight and shade the interior branches of the tree. The flowers become yet more evident as they reflect the sunlight, framed by the deep shadow behind. Each circle is divided. The outer ring with large tabular petals forms a rosary to catch the eye. The central flowers are by comparison tiny. Their petals are short, the slight yellowish colour appearing subdued next the purity of the white outer ring. Thick with pollen, they are cluttered. The larger flowers that surround them are alluring but sterile, a siren deceit, with none of this disruption to their virginal surfaces.

Mid-morning and the sun has already been above the willow for five hours. Its visible trajectory, beginning with turning the condensation from an unclouded night to mist and then to the thinnest vapour, has already taken it high above the hawkbit and catsear. Detaching from skirted heads, their parasolled seeds float pendulous, rising and falling on unseen thermals. The radiating heat causes both wind and plants to twist and pull.

The patterns of delicate greens, white and a veining of black that make the guelder rose are broken as movement, charged by the sun, disrupts the surfaces of flowers and leaves. Across a leaf a figure creeps, its legs stiff but confident in each step. Rosewood eyes and long stretched mandibles lead to a body of polished ebony layered with ivory. The end of its body curls, its colour now reflecting the orange-red of the mandibles, in a semi-circle that reaches a bulbous end, twin spikes crossing at its tip. The wings are translucent but marked with sections of solid black. It is a scorpion fly, a male with an arched, spiked tail which it uses to grasp the female during copulation. It broadens its wings into flight. Traversing the vegetation that surrounds the streams, it will look for dead insects to feed upon, using its extended mandibles to steal meals from spiders' webs.

My eyes are drawn upwards to a fly with a body that gleams with a metallic gold. Coarse with hairs, the body, including the red half-sphere eyes, is thickly covered with pale yellow pollen as it pushes through the central flowers of a sunlit garland. It is consuming excess pollen as well as distributing it. Its faceted eyes absorb the changing light and movements that include me as I sway back and forth, shortening my breath so as not to disturb it. I wonder if it has any sense of my nature, this yellow dung fly: whether I am plant or animal. It certainly has the

ability to recognize other insects, swooping down on them to grapple with them and feed.

Behind me a bluebottle with the wonderful scientific name of *Calliphora vomitoria* sits on a stem of great burnet, a meadow specialist. It shines with a patina like the bluing of a rifle barrel. Holding on to the beaded surface of an unopened flower head, it effortlessly raises itself into the air on two legs and fastidiously wipes and cleans itself with the remaining four.

The sheer variety in the appearance of the flies is inestimable. Studying the grasses, bushes, trees and the air around you reveals countless species, from small, blood-red gall gnats that hang from vegetation to the aphid-eating larvae of hoverflies and horseflies with eyes patterned in psychedelic colours which run the risk of being pounced upon by waiting robber flies. With over 7,000 species in the UK flies fill every ecological niche from controlling pests and breaking down waste through to pollinating wild plants and crops which provide food not only for people but also for birds and mammals, all of which rely on a continued supply of vegetation, fruit and seeds to survive. And of course they are a food source themselves, to the hunting birds and dragonflies that dance in the air.

Bees too fill the meadows. Early mornings find them unresponsive, embracing the plants. Later the bullet forms of honeybees contrast with the boiled-sweet-and-lint figures of bumblebees making yoyo flights.

A damp and temperate climate suits the bumblebee, with the UK containing a tenth of the world's species. Their foraging leads them to plants rich in nectar, such as red clover, a staple. In search of a continuous supply of this sugar-rich solution, they are industrious from April through to August, wings blurred and consuming a huge amount of energy. Their activity makes them a key source of pollination.

The honeybee is also well recognized for its importance in pollination. With movements like erratic dancing it directs hive mates to sources of nectar and pollen. With an increase of 38 per cent in insect-pollinated crops in the UK since 1989 the honeybees work ever harder, albeit unknowingly, towards improving yields.

Those thick but brief summer mists encrust other animals with droplets. The first rays of sunshine touch the webs of the spiders, the light refracting into rainbows that are fractured into drops, giving an impression of the unseen threads. With legs that reach out to touch the webs' trigger lines the spiders have myriad body shapes and colours. Common species such as *Araneus diadematus*, the large and charismatic spider that fills our gardens, wait on rush stems or hidden in curled leaves at the limit of their webs. A crucifix of white splashed on their backs interrupts the variable colours of the woodland floor. The tiny body of the cucumber spider is distinct in the fluorescence of its abdomen, the most vibrant of greens. Capable of moving rapidly, the cucumber spider is smaller than

many of the grass flowers it climbs. The larger *Tetragnatha extensa* sits in knee-height vegetation. With long mechanical legs, the front pair longer than the rest of the body, it reaches and manoeuvres. Its body is shaped like an aubergine, long and narrowing towards the tip. Striped greens and browns along its length create the impression of an exotic gourd. Trailing web, it narrowly misses the cuckoo spit hanging from bindweed, a froth that protects a froghopper nymph, one of the teardrop-shaped insects that, as adults, leap, propelling their aerodynamic bodies remarkable distances. Rejecting the static web, wolf spiders run on a circular arrangement of legs and pounce upon prey. The females can be seen carrying large spherical egg sacs beneath their bodies in an act of maternal protection. Again, with 650 types of spider in the British Isles, their variety is appreciable.

The ubiquitous common blue damselflies hang alongside banded demoiselles and the larger dragonflies. As with the snake's head fritillaries, the early morning drops pick out their bodies, creating glistening silhouettes against the sun. The damselflies fly low, catching flies on the wing. Sky-blue males and females that blend with the grasses circle to form the shape of a heart as they join to copulate. The dragonflies are heavier, broad and aggressive as they rise from the grasses to above the hedge lines. They pause on leaves to rest or feed on the insects they catch. In the streams below, their nymphs, with gruesome features, spend years catching unfortunate fish and tadpoles before they climb the reeds where they transform into winged adults.

With over 180 recorded plant species and the complete absence of pesticides it is no wonder that the invertebrate population of Clattinger Farm is high. Every level, from beneath the ground to the clouds of butterflies and moths tumbling across the meadows, is filled with activity. The importance of the grasslands in the survival of these smaller creatures cannot be overstated. Few people realize the sheer numbers of invertebrates we are surrounded by. More than 200 solitary bee species and 4,000 beetle species are just a portion of the insects estimated to make up 75 per cent of the UK's terrestrial species. This makes insects the largest part of British biodiversity on land. Combine this with the fact that 80 per cent of British plant species utilize pollinators, most of them insects, and you get some idea of their importance.

Each plant in the meadow has partners and animals that rely on them. Most butterflies, for instance, rely on a handful of plant species to feed their larvae. Each year the dancing adults descend, seeking out their niche in the floral carpet to find the right plant on which to bring their young to maturity. Similarly, the common blue searches for bird's-foot trefoil. Single sea-urchin-like eggs that appear on the young growth of Clattinger's blackthorn in August are laid by the rare brown hairstreak, to hatch the following May. Such interdependencies rule this miniature life. In turn the resulting success leads to food for skylarks,

cuckoos, swifts and other animals that disrupt the invertebrates' ordered world. With the loss of meadows plant partners lose their food sources.

Specific plants, like the caterpillars that feed on them, have their own particular niche. Devil's bit scabious, tall, wire stemmed with indigo heads, swaying above the white froth of hawkbit seeds and the yellow highlights of lady's bedstraw, relies on the moist, unadulterated soil. In turn, the marsh fritillary rejects all but this increasingly hard-to-find flower as a place to raise its young. Both are in decline. A European Environment Agency study between 1990 and 2000 looked at trends in butterfly species in the then twenty-five members of the EU. Over this decade it observed a decline of a shocking 28 per cent in the numbers of butterflies, while 51 per cent of the 576 butterfly species recognized depend on grasslands for their survival. Information collated by the Butterfly Conservation Society showed that 72 per cent of the UK's butterfly species declined between 1975 and 2000. The richest sites were on limestone or chalk, like the calcareous grasslands here, and the biggest losses were in those feeders that require the plants that survive only in low-nutrient areas such as these meadows.

Moths that fly by night and those, like the coal-black, silver-tipped chimney sweeper, that also fly by day, are being affected too. Surveys of 337 common species from 1968 to 2002 found that two-thirds were declining, with the total amount caught down by 44 per cent. Again, with many of these species reliant on the plants contained with these grasslands a connection is clear. With all 17 British bat species feeding on moths in varying degrees, the effects of these reduced numbers reach beyond this insect family.

Universal themes connect the plight of many of the invertebrate species that occur here. Disappearing habitat is key. Specialized food plants for those invertebrates that rely upon one or a few plant species plus the successive supply of food throughout the season for nectar feeders are both largely absent in the modern monoculture crop. The heavy use of pesticides can bring death or impaired condition. Isolation and inbreeding are here again, especially with those species that cannot travel far.

With the collapse of one species comes the impact on their partners. For instance, without the ant species that raise their larvae the specialized butterflies of the blues family would fail to survive. The invertebrates' connection with the seed and fruit feeders, whether wild animals or ourselves, is something not to be ignored.

When you walk through such a rich habitat each footstep is preceded by a wave of invertebrates. Their leaps and flights, following the direction pointed by the stems, make it appear as if these animals are an extension of the plants around you. I cannot help but think that in a way that is indeed the case, so important, so fundamental, are they that without their presence the existence of the plants, the wildlife and ourselves would be unrecognizable.

Bluebottle (*Calliphora vomitoria*)

Gall gnat (*Cecidomyiidae* species)

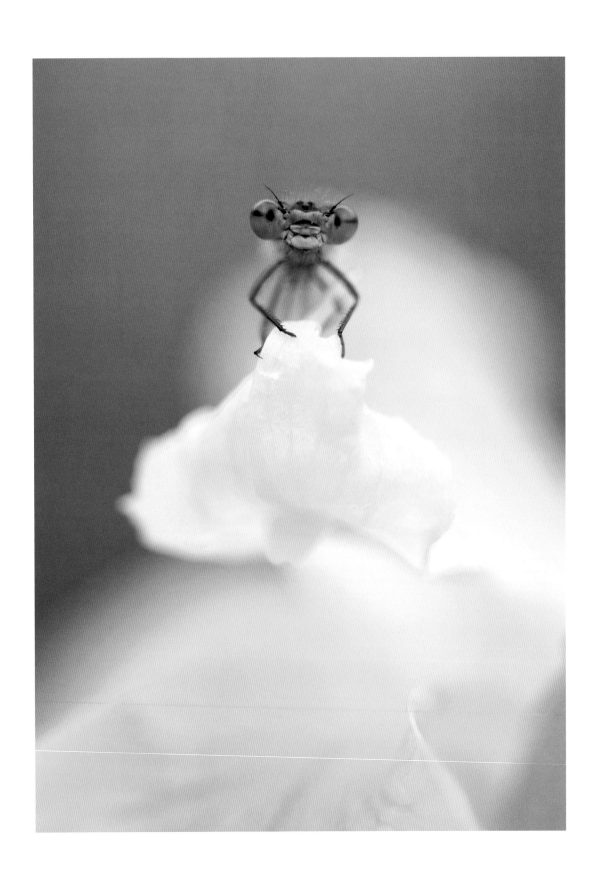

Common blue damselfly (*Enallagma cyathigerum*)

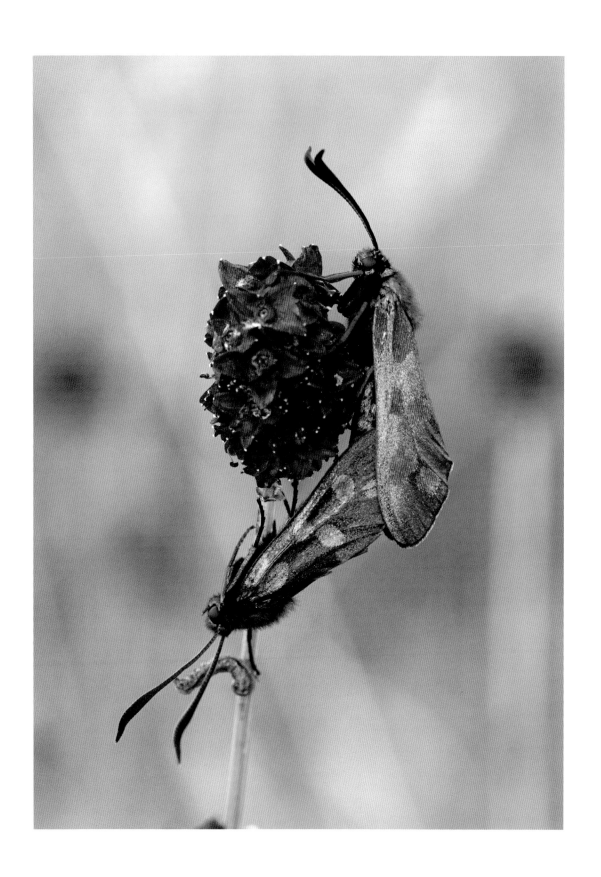

Six-spot burnet moths (*Zygaena filipendulae*), mating

ABOVE LEFT Rough hawkbit (*Leontodon hispidus*) and aphids (*Aphidoidea* species)
ABOVE RIGHT Cucumber spider (*Araniella cucurbitina*)
RIGHT Cow parsley (*Anthriscus sylvestris*) with mosquito (*Culicidae* species)

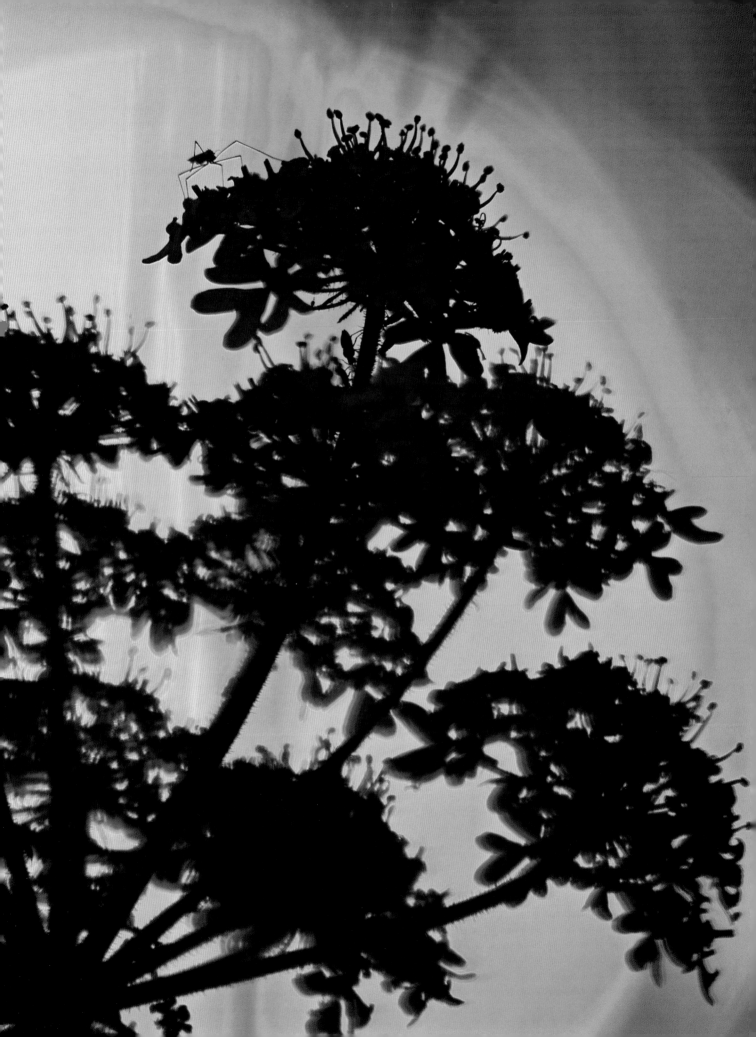

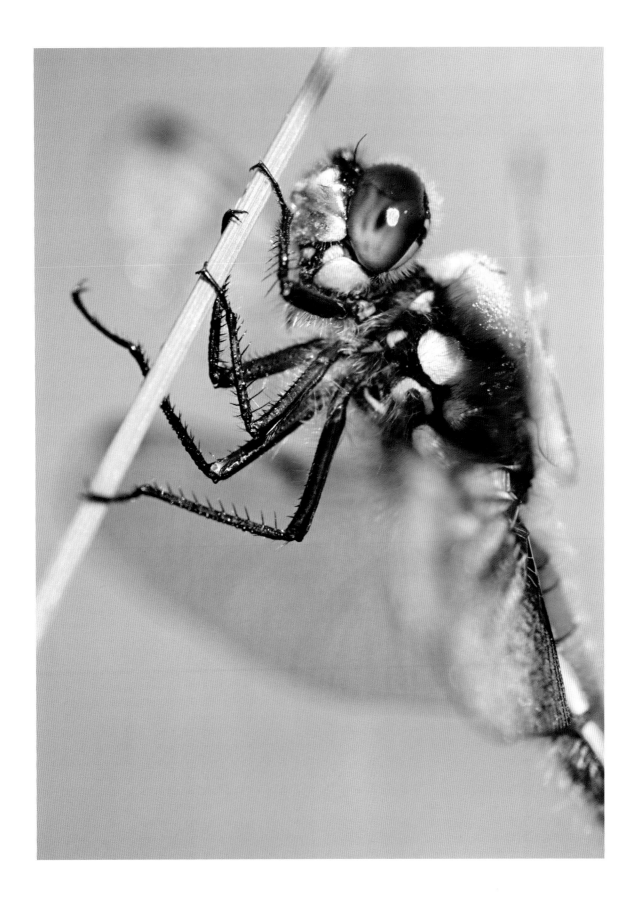

LEFT Yellow dung fly (*Scathophaga stercoraria*)
ABOVE Four-spotted chaser (*Libellula quadrimaculata*)

Yellow or brandy bottle water lily (*Nuphar lutea*)

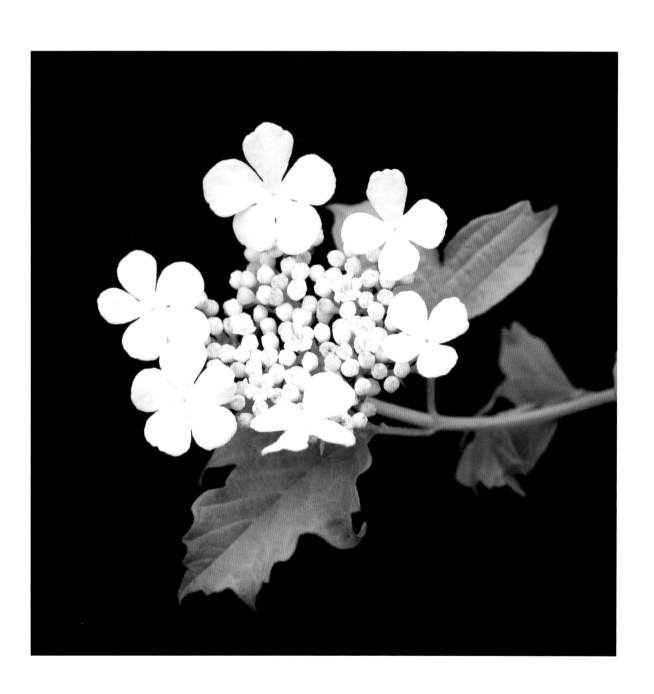

Guelder rose (*Viburnum opulus*)

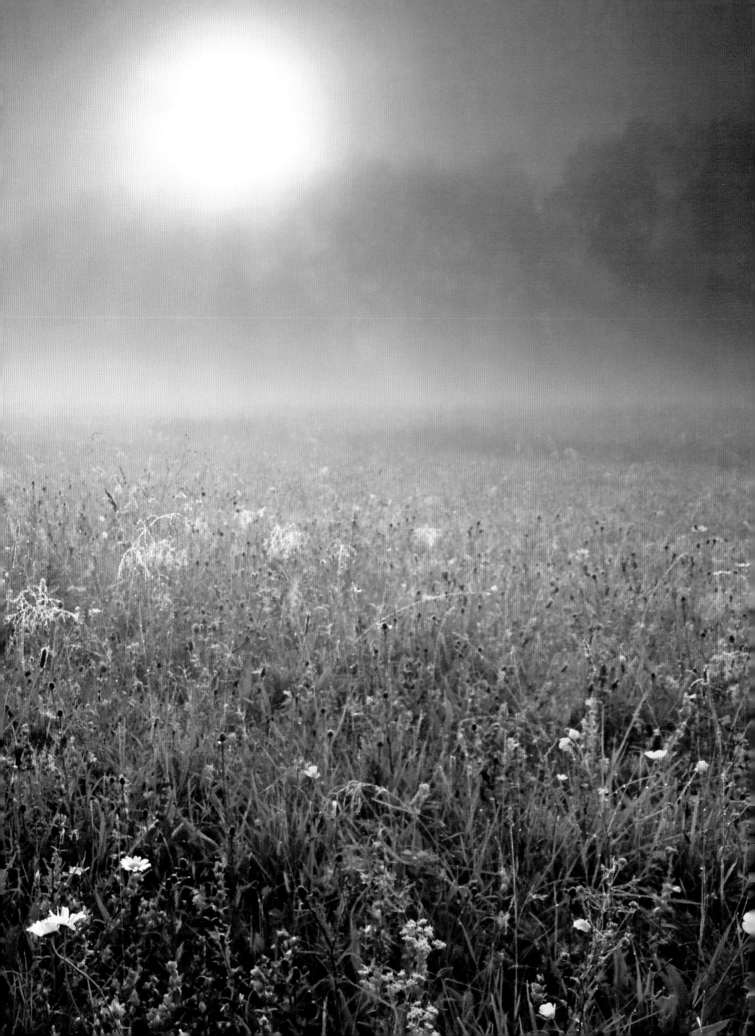

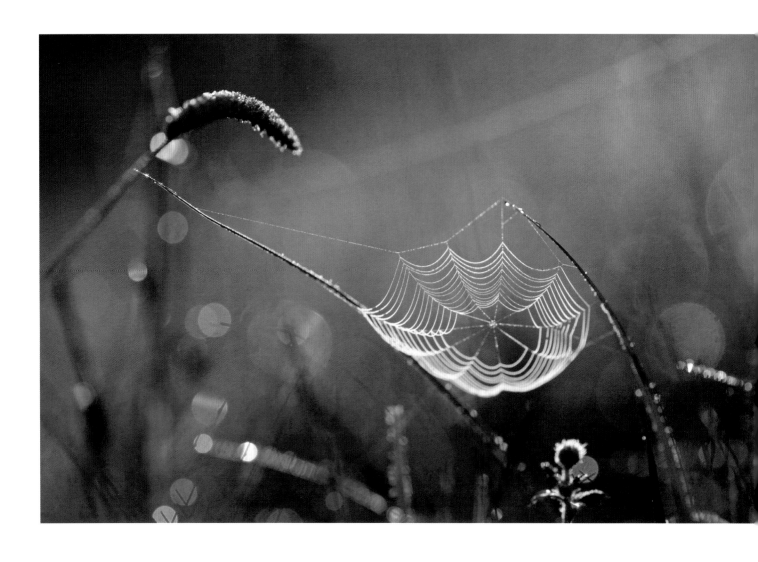

PREVIOUS PAGES Rising sun and mist
ABOVE Spider's web diffracting light
RIGHT *Tetragnatha extensa*

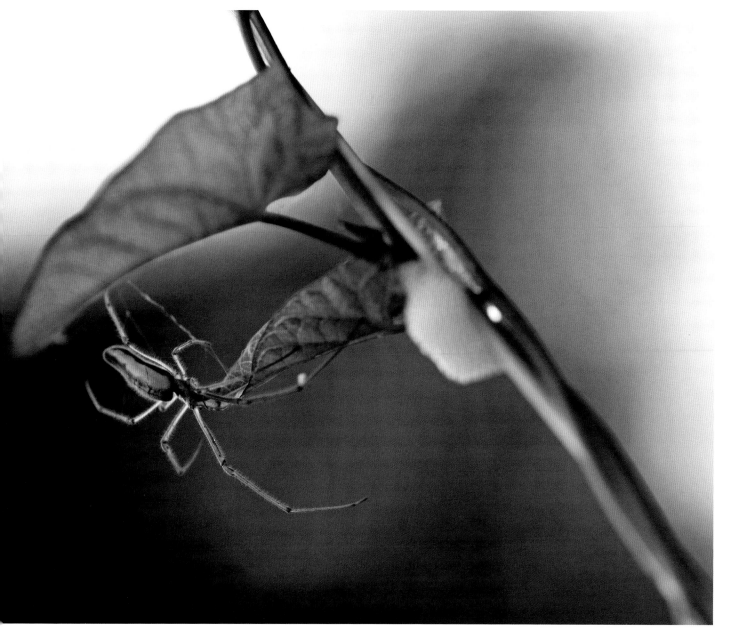

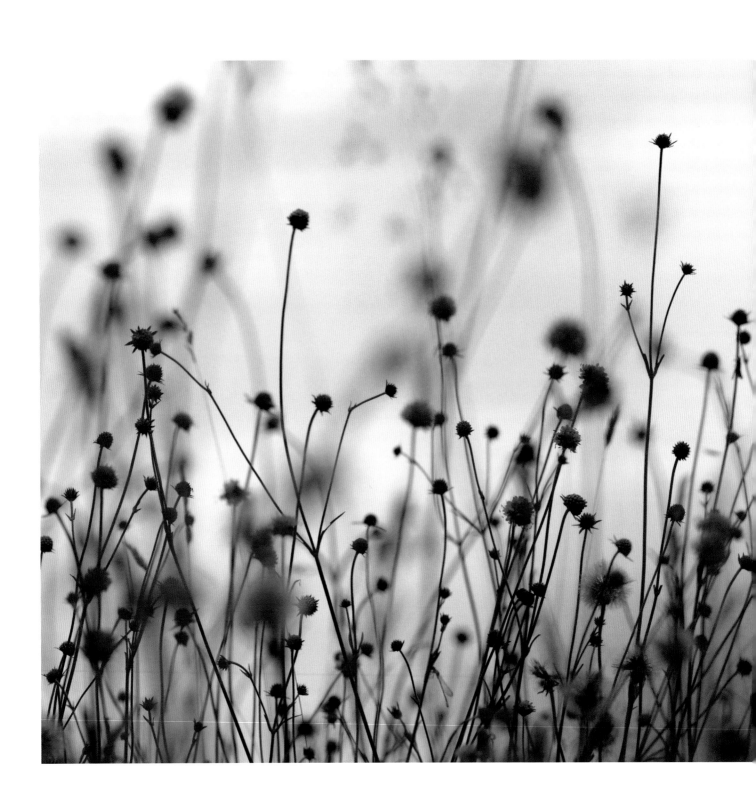

ABOVE Devil's bit scabious (*Succisa pratensis*)
RIGHT Male common blue butterfly (*Polyommatus icarus*)

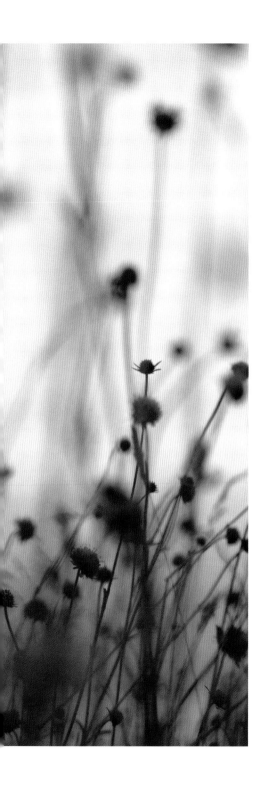

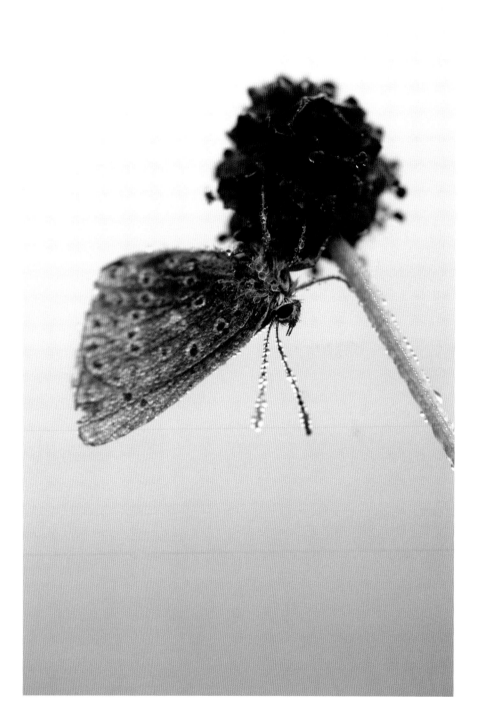

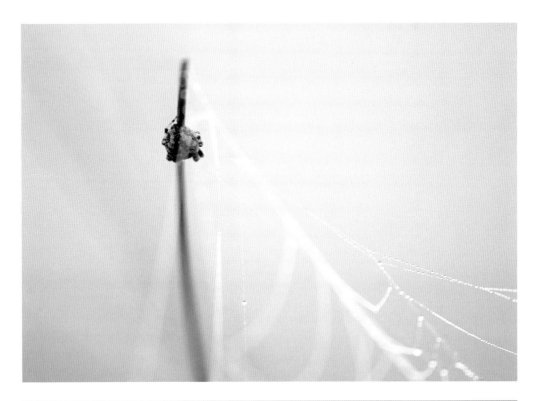

TOP *Araneus diadematus*
BOTTOM Spider's web
RIGHT Creeping bent (*Agrostis stolonifera*)
FOLLOWING PAGES Overhanging field maple (*Acer campestre*) with bulrush (*Typha latifolia*) leaves
and yellow water lily (*Nuphar lutea*) by one of the streams surrounding the meadows

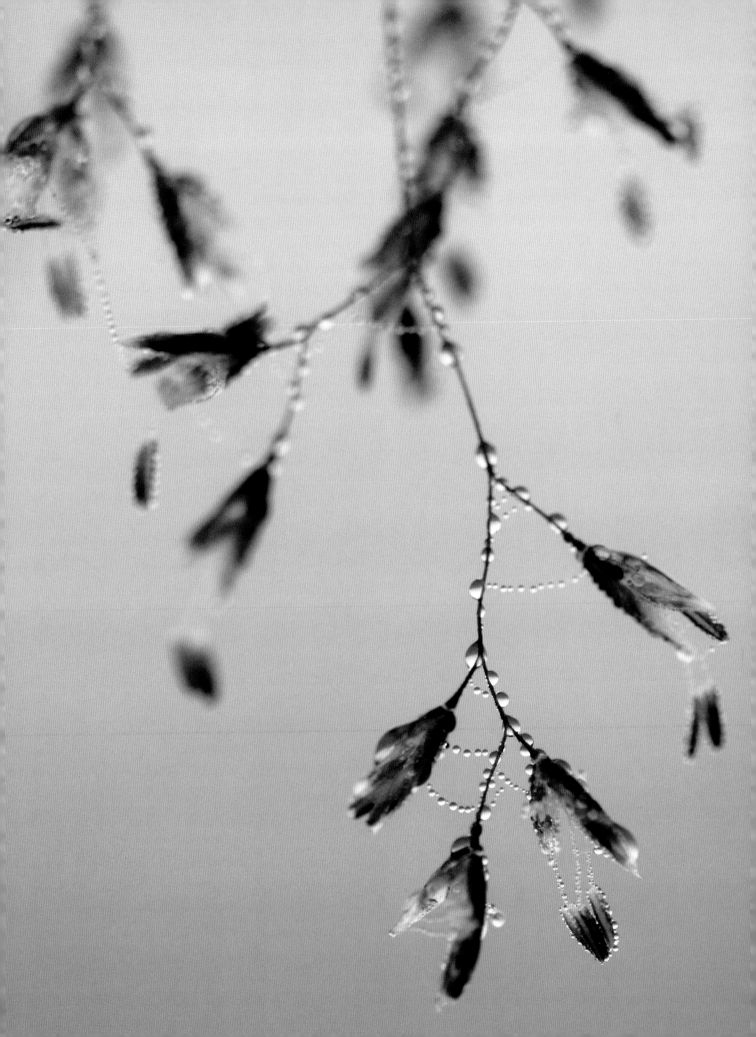

5. Seed and fruits

The sky has changed. Morning saw it developing into a rich blue. White, long-tailed clouds ran in parallel strokes. Against my skin I felt the wind gusting in breaths, dense, bringing a cool to the heat of early July. Now the plains of cloud, extending solidly to the horizon, have become silvered, their texture near flat. Diffused light softens the landscape; shadows that support and separate each plant and tree are almost absent. Tinted blue, the light seems to drain the warmth from the drifts of flowers. At a distance they become almost monochromatic.

Across the county the fields are shorn. Tractors cut through waist-deep grasses, once thick and verdant, now bronzed. Speeding over the rows of bristled stalks balers race the weather as they whirl the slashed stems into bales. While May saw the first fields of grass cut, wrapped in black plastic to ferment into silage, a couple of months before most of them set seed, the current cut is destined for hay. The bare fields, once filled with swaying stems that described the wind and level with their neighbours, have become depressions among the other fields of crops. Rape has lost its sulphur-yellow flowers; now only the cold-water blue of its foliage can be seen. The occasional patch of linseed blooms and the gold of ripening wheat lighten the patchwork.

At Clattinger Farm, however, the plants remain undisturbed.

Among the wind-hardened stems of knapweed and meadow oat grass the seed cases of yellow rattle spread in clusters. In growth the plant has yellow flowers with a serrated leaf whose edges turn upwards, earning it its other name of cockscomb. Now its desiccated stems feature only circular seed cases that shake percussively. The seeds that fall from these cases are a key part in the meadow's success. This perennial is semi-parasitic: its roots feed on the rhizomes of the more dominant grasses. In doing so it suppresses the vigour of the grasses', which means that other wild flowers, more delicate and less aggressive, can compete against and prosper among them.

Elsewhere the wind lifts the seed from Jack-go-to-bed-at-noon, otherwise known as goat's beard or salsify. Gossamer banding weaves a canopy, concave above the seed's stem, which carries it on air currents. Like delicate umbrellas, the seeds stall momentarily on eddies above the hedgerows.

Dandelions, too, are losing seed. Striking the stems of other plants the seeds rebound and fall rapidly, sliding to the ground. Their weighted bases pull them downwards, the upper filaments bending as they resist the direction of travel. Soon the bases will detach, leaving the seed. Tiny, long and slightly rounded, the seeds do not appear exciting at first, but magnified they seem altered. Curving gently, their surface is ridged, covered in woody

barbs pointing to where the canopy used to be. These barbs act to ensure that, when pushed into the ground, the seeds are unlikely to be removed.

The seeds reflect the intricacies of the flowers, their uniqueness and ingenuity. The variety is astounding. The scaly bananas of Jack-go-to-bed-at-noon, the carved spinning top of common agrimony, the humbug-striped ox-eye daisy, the hand-beaten cannon balls of bluebell, the hairy grooved tongues of devil's bit scabious. Yellow flag iris has asymmetric, berry-sized seeds like carved mahogany; red clover, rounded kidneys ranging from wheat yellow to the brilliant red of rubies. The seeds of tufted vetch are like the eggs of long-extinct animals, speckled with delicate patterns. Crested dog's tail seeds are the shape of flames, their centres hollow with an exposed spine within and the outer texture roughened like sandpaper.

The meadows are thick with seeds. Most are reaching maturity. Plants stoop, laden under their weight. Many of them are expelling the last of their energy to bring the seed and encapsulating fruits to maturity. As with any other successful life form, the plants strive to reproduce, competing for biological success.

In another few weeks a tractor will be in these fields, passing back and forth as it reduces the swathe of herbs to a flattened thatch. Insects will crawl from the vegetation, only to be swooped upon by the birds that follow the topper's progress. The seeds, now mature, will become detached and be spread over the surface of the denuded meadows. Those extra few weeks of maturing ensure that they will be ready to continue the cycle next year.

In the hedgerows berries are plentiful. The blackberries are turning from aphid green to alcoholic red and finally into the black of polished brogues. At this time of year the berries still possess an astringency that balances the rich sweetness of their flavour. In the globules that heap to create each fruit are the finest of seeds. Each has the potential to become a new plant, which will stretch thorned tendrils to make the latticework banks that will bear flowers with crinkled petals, which will bear berries that shift dark greens in autumn to oranges, reds and the same purple that stains the hands, feathers, exoskeletons and fur of the animals that feed upon them.

The sloes are still green but just showing hints of the midnight blue they will become. Likewise, the haws have none of the bright red that will fill the hedgerows in autumn. The ivy will not begin to flower for two more months, when its berries will provide a valuable late-season food source for pollinating insects. Together these fruits give a large supply of food for many birds and small mammals in autumn and winter. In return, and without the competition of other food sources, the animals help to distribute the seeds the fruits contain.

Were attention not paid to their seasonal cycles the plants among the grasses would not fare so well. The few weeks of patience required to delay cutting the meadow results in a habitat that can in turn tend itself, maintaining its value with little intervention. This is the advantage of working with the natural world.

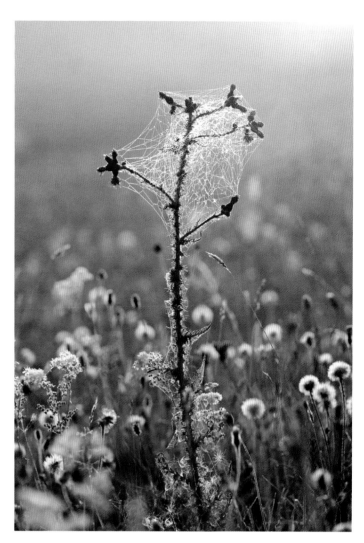

PREVIOUS PAGES Ripening plants in the meadows
LEFT Common sorrel (*Rumex acetosa*)
ABOVE LEFT Meadow oat grass (*Helictotrichon pratense*)
ABOVE RIGHT Marsh thistle (*Cirsium palustre*)

ABOVE Dandelion (*Taraxacum officinale*)
RIGHT Goat's beard or Jack-go-to-bed-at-noon (*Tragopon pratensis*)

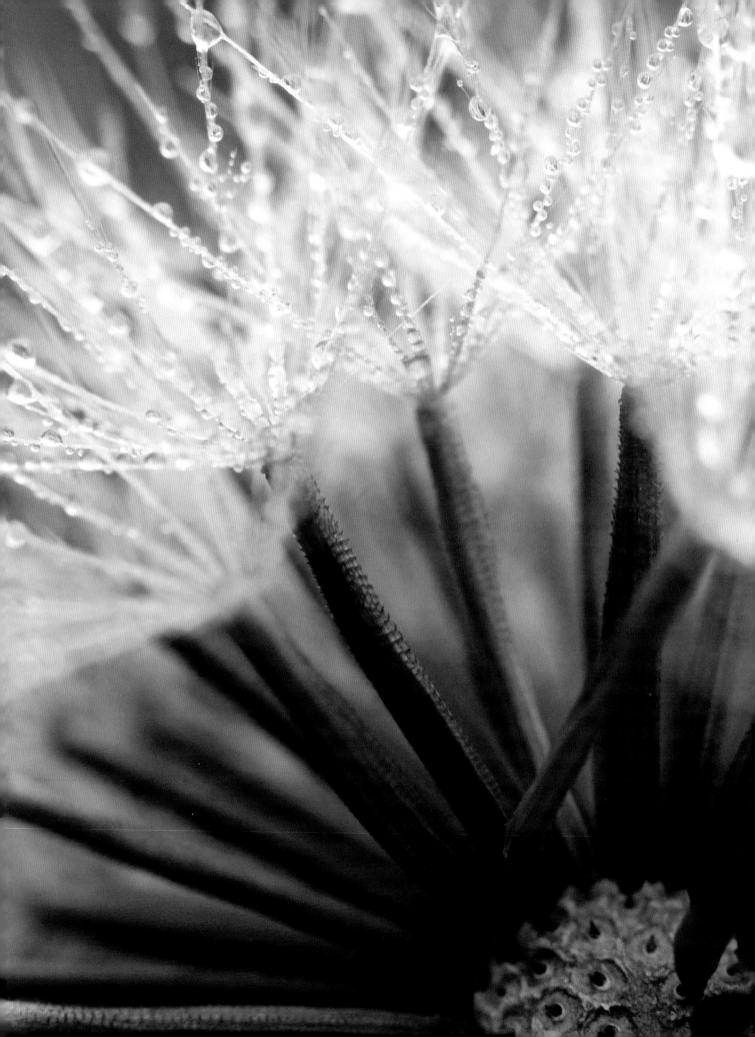

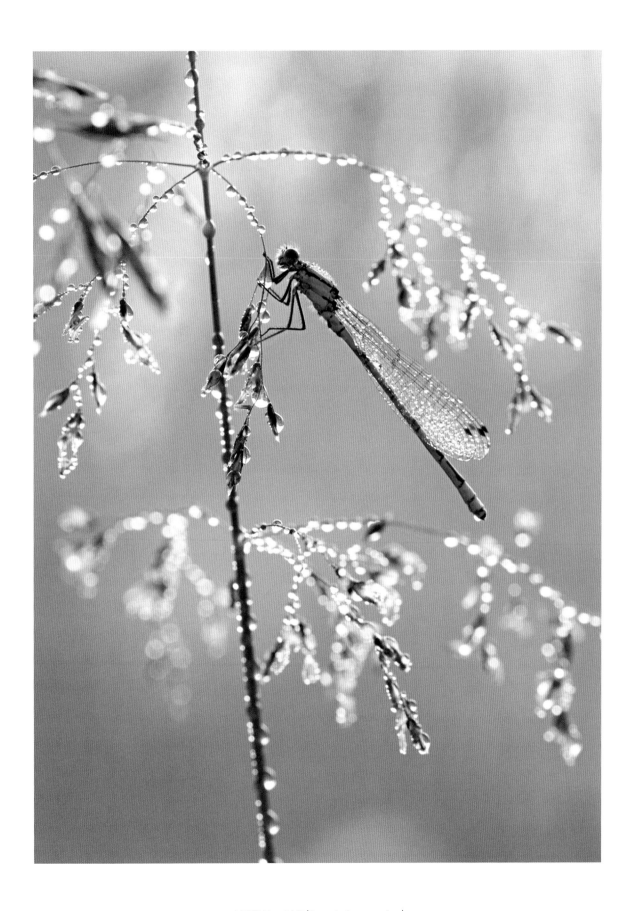

LEFT Hawkbit (*Leontodon* species)
ABOVE Common blue damselfly (*Enallagma cyathigerum*)

Blackthorn (*Prunus spinosa*)

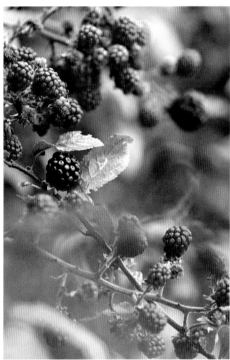
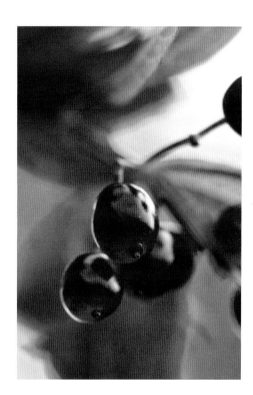

LEFT Hawthorn (*Crataegus monogyna*), with frost
CENTRE Blackberry (*Rubus fruticosus*)
RIGHT Guelder rose (*Viburnum opulus*)

ABOVE LEFT Common hazel (*Corylus avellana*)
ABOVE RIGHT AND RIGHT BELOW Blackberry (*Rubus fruticosus*)
RIGHT ABOVE Guelder rose (*Viburnum opulus*)

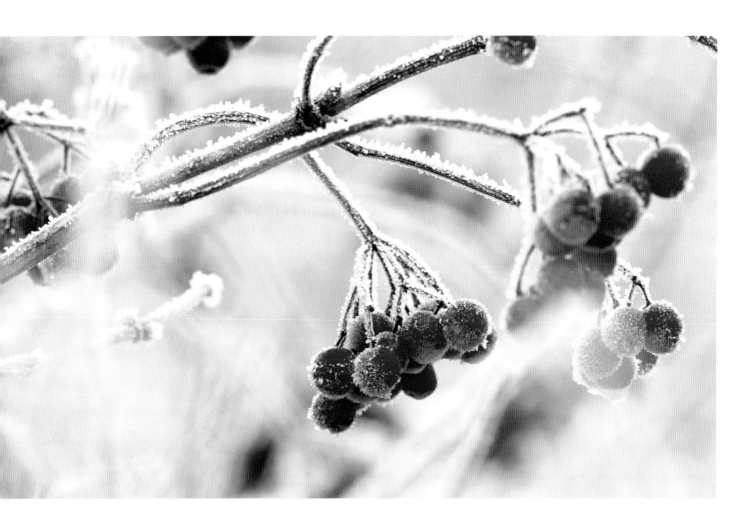

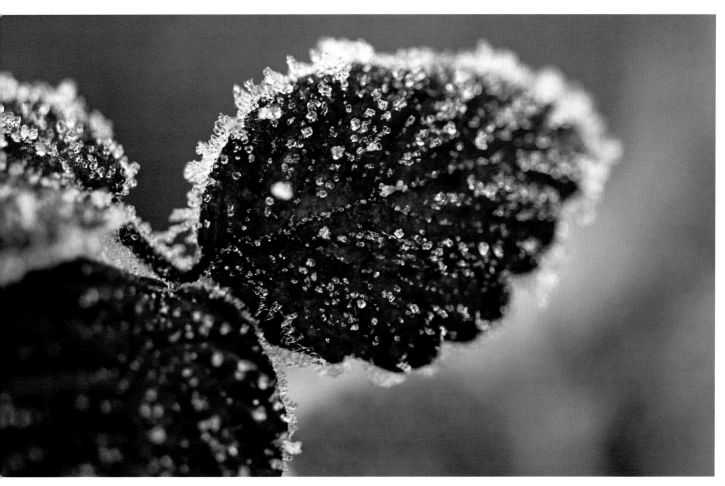

6. Maintenance

I watch autumn pass. Fogs that turn the sweeping fields to the shallowest of views, murky and miasmic, cover the stems of herbs, the green becoming lighter as the days shorten. Winter migrants begin to arrive: waterfowl slipping from altitude to the surrounding lakes, fieldfares clattering over their choice of berries. The flight of birds, which strip fruit or invertebrates from the fields and hedgerows, is continuous. Rooks pass overhead, the fog draining their colour until, distant, it absorbs them.

Belted Galloways, their eyes set in black faces, spherical and glistening, with black eyelids and curving black lashes, watch with apparent docility. I approach them. The cows are split by a band of off-white looping their mid-riffs. Their shining nostrils and lids widen with what appears to be apprehension, heightened no doubt by the presence of their calves. Outside the phalanx individuals radiate as they take slow steps, clipping plants.

Aftermath grazing sounds apocalyptic, final, as if it means the clearing of the last remnants of use before destruction is absolute. In fact the aftermath is more passive than its name suggests.

The first frosts and clear skies lift the meadows. The low sun rings the cattle, illuminating the fiery undertone of their pelts. The delicate light and the thin white coating give me the impression of cleanliness. Part of this reaction owes itself to the purpose of the livestock here. The cutting of the hay in July takes away the vast bulk of the vegetation. Soon plants begin growing again, never free from competition. Tough, needling rush leaves and grasses fuelled by food stored in rhizomes soon gain height. The browsing of the cows, their numbers restricted so that they do not overgraze or churn the fields too much, suppresses the growth of these flourishing species. More than this, they strip out the seedlings of trees and shrubs that would swamp and outcompete the wild flowers, so preventing the meadows from reverting to a scrubland. This levelling is done before the worst of the winter weather, when the plants' growth becomes highly restricted. This creates a more equal footing for the explosion of growth that will follow with the approach and beginning of spring. Perennials will not be overshadowed; seedlings of annuals will have a relatively free path as they grow towards the light. In this way the agricultural intrusion, the aftermath grazing, not only supports the health and growth of the cattle but also improves and maintains biodiversity.

The concepts of the natural, nature and the influence of man are regularly

misunderstood. We look at our landscapes, from sweeping grasslands to woodland valleys, and see nature at work, yet there is almost no land in the UK that has not been shaped through the influence of man. Today 76 per cent of the UK's land area is utilized for agriculture; 65 per cent of that is grasslands, of which only 5 per cent are permanent and unimproved. To remove humans from our view of the natural world would be to discount our role in maintaining or destroying its balance.

Across the world, the expansion of people in number and area combined with the reduction of pristine habitat means that there is a new reality to face in conserving biodiversity. The idea of the complete segregation of people from species-rich environments is a rare possibility and in certain cases can put both habitat and local people under increased risk or hardship. This fact is especially pertinent when we consider the proximity of almost all biologically rich areas to human populations. Finding approaches to utilizing the natural environment for people – whether through tourism, recreation, agriculture, subsidy or a combination of these things – in a way that supports biodiversity rather than attempting to subjugate it can turn people from opposing the natural world into becoming its custodians, reliant on its continuation.

To talk of subjugation, however, is unfair to many who work our landscape. Too often in the past views have been simplified, polarized to suggest that there is a good-versus-bad battle. The complexity of balance requires more respect.

Before 1930 restricted finance meant that there was little additional farming input on the land such as commercial fertilizer, herbicides and pesticides. With farms relying on a mixture of crops and livestock rather than monoculture, wildlife was on the whole much better supported. After the Second World War the drive to stem food shortages across Europe and develop self-sufficiency saw the face of agriculture change. Focus was given to maximum returns for land area. This was further increased when, in 1973, the UK joined the European Economic Community (EEC). This included the Common Agriculture Policy (CAP), which included a fund contributed to by and dispersed among partner countries. At this time, the CAP – based on an agreement of 1957 – worked to ensure food security, affordability and fair prices to farmers and to increase productivity. These aims are admirable and still form very valid aspirations. Farmers were rewarded for yields and as a result, to fulfil targets and to ensure their livelihoods, they adapted

their approach. They removed hedgerows, enlarged fields, changed crop seasons, seeded, fertilized and cut grasslands several times every year for silage, and increased livestock density. The results were impressive, with the production of wheat and milk averaging an annual increase of 2.3 per cent and 1.8 per cent respectively between 1946 and 1993.

However, today our perceptions and priorities are changing. The crucial role of the natural world in sustaining our own race is becoming increasingly evident. Whether this is as a genetic store to help crop development and medicines, in pollinating the species we need to survive or in helping to prevent or provide a buffer to natural disasters that affect people, we are beginning to understand the necessity of preserving and helping it.

As the CAP has developed and the value of conservation has begun to be understood it has been recognized that funds need to be allocated to help farmers do this. A proportion of CAP funds now supports agri-environmental schemes. In the UK today the most recognizable of these is England's environmental stewardship scheme. Farmers are rewarded with subsidies according to their actions. Approved actions range from leaving uncut margins to support insects, plants and small mammals, and planting of seed mixes for farmland birds, through to targeted schemes for supporting locally restricted species. Currently 70 per cent of England's agricultural land is under one of the various agri-environmental schemes available, in over 57,000 agreements. This equates to almost 6.5 million hectares of land.

If we want the wild species of the UK to be maintained, increased and protected, however, we need to be willing to help our farmers even further. The near complete loss of one of our richest habitats in just 60 years shows the potential of our decisions.

Loss can, though, bring hope and innovation. The Wildlife Trusts in their various forms, including Clattinger Farm's owner, the Wiltshire Wildlife Trust, have been working to benefit wildlife and educate people about it since 1912. Recently their work has taken a new turn. In nature reserves many species become isolated. The consequent threat of inbreeding, and the lack of ability to travel and adapt in response to climate change and continued habitat losses, put wildlife, plants and, just as importantly, habitats, at risk. Cognisant of this, the Wildlife Trusts have created the Living Landscapes concept.

This idea addresses the state of nature beyond reserves. The creation of a more complete landscape management style, which looks at how we can work with and utilize nature in land use and conservation, puts the trusts' focus on a much larger scale. Identifying the various landscapes of the UK, they are helping landowners to create vast wildlife corridors of mixed habitat, extending beyond single owners' boundaries. These corridors ensure the space and conditions

needed for our flora and fauna to travel, meet, adapt and regain lost ground. Approaching the division of land in this manner exposes a key truth: nature is not supposed to be compartmentalized and has a key role in the UK in its entirety, and in every country beyond. With sympathetic management like this we in turn will reap the benefits of a greater level of biological stability and all the other positive effects that that brings.

Clattinger Farm is playing its role in achieving biological stability, as is Blakehill Farm, one of Wiltshire Wildlife Trust's recent acquisitions. This ex-Royal Air Force base covers an impressive 240 hectares, making it the largest of this trust's reserves. Largely unimproved, this vast area of land is one of the most ambitious grassland restoration projects in the UK. Seeds left to ripen in the fields of Clattinger Farm have been bundled with the hay, still fresh and green, and transported to the fields of Blakehill Farm, where they have been spread, bringing the richness of Clattinger Farm to the new site. Once again, it is being grazed with traditional cattle and sheep. With thousands of plants already established, these grasslands will continue to regenerate over the next two decades, becoming one of our most stunning, species-rich and near-lost habitats.

With this long-term planning Wiltshire Wildlife Trust is creating a benefit that can be applied beyond the UK's boundaries, while looking at countries that have lost significant amounts of habitat can help us realize a more sensible approach to farming and caring for the large remaining habitats both in Europe and worldwide. By accepting the responsibilities that this demands of us, we can move towards the large-scale preservation of biodiversity for generations to come.

The robin is like a flare. It perches on pure white branches, thorns of hoar frost projecting at every angle. Everywhere is white. Its red breast screams its presence; the body is spherical, inflated against the cold. The crystals of frost form enormous spurs, stacking up and repeating outwards on every surface. The circumferences of trunks and branches are enlarged by this coating but visually they merge, a mass of the most delicate shading. Brilliant in their purity, the edges melt into the cloud. The occasional crystal drifts and lands on me, and when I observe it, it disintegrates under the warmth of my breath. The branches of an ash hang low. Seed cases, like chandeliers drawn to a point, show hints of brown, scored downwards by their mass. The remaining few bramble leaves are inscribed with exaggerated patterns; the brambles' thorns are blunted by the ice coating.

The hardness of winter, the homogenous appearance cast by the encasing frost, seems to contradict the faded memories of spring. But in a couple of months we will have cowslips, snake's head fritillaries, stitchwort and cleavers again, growing in a roaring crescendo, a washing and enveloping life. This prelude, still and quiet, builds up my anticipation; it is an absorbing calm before I am once again consumed.

LEFT Meadows after cutting
ABOVE Belted Galloway cattle (*Bos taurus*)

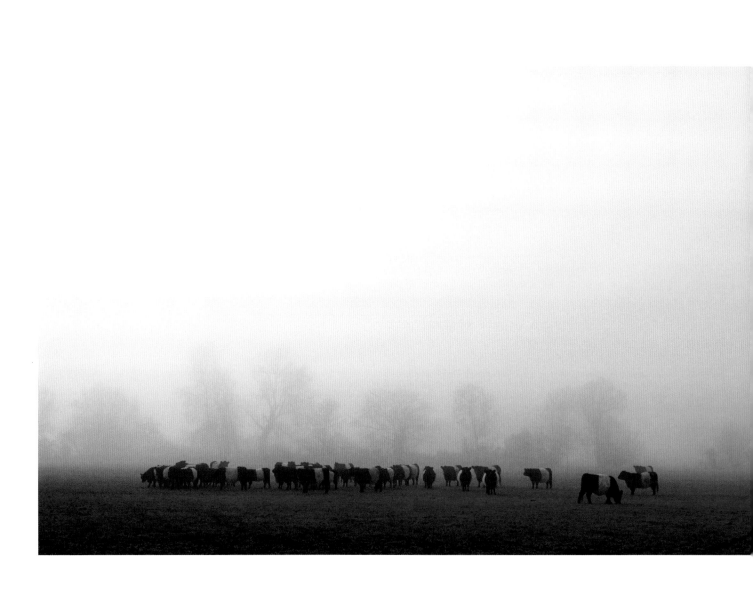

Belted Galloway cattle (*Bos taurus*)

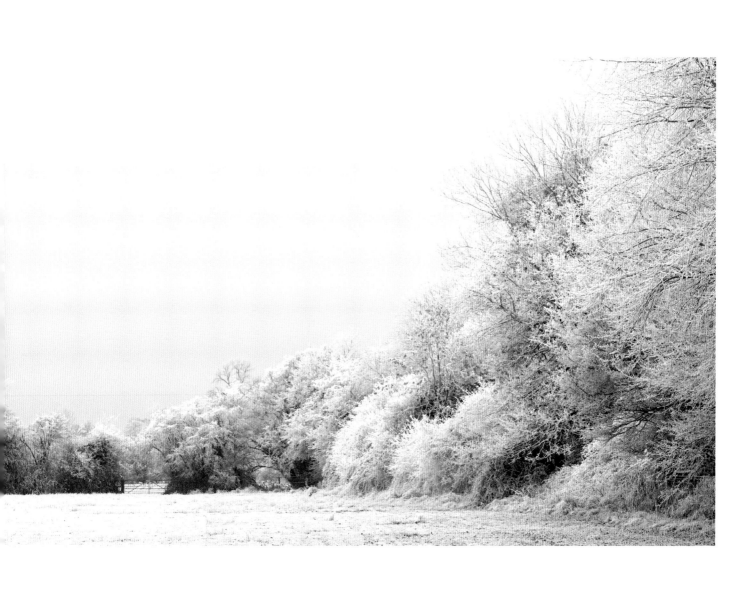

ABOVE Hoar frost in the meadows
FOLLOWING PAGES Sunset over the meadows in summer

How you can help

My own experiences in these meadows are those of somebody with no expertise in natural history. My work as a photographer has simply been driven by a keen interest in the natural world, which enthuses and concerns me.

To be involved in helping to encourage conservation, whatever the habitat, you need little more than interest. Many of the charities and groups listed below hold walks, talks and volunteer days for habitat restoration, in both rural and urban locations. Why not combine a stroll, a meeting with a friend or even a date with one of these, which may open your eyes to facets of the world you are currently unaware of? The small fees and attention you will provide can help continue the charities' work and show that there is genuine interest in and support for the natural world. Take a step further and join a membership scheme to give consistently and in return receive more information on the exciting species and habitats that surround us. The greater the numbers of people in such schemes, the more likely it is that we will be able to influence policies to make sure that the future is positive for the natural world.

It is important not to forget to share these experiences with children. After all, we are looking to benefit the future. As well as involving them in organized events, why not give a child a compact camera? With cheaper technology, free from the expense of film, it can be a wonderful tool in encouraging children to look more closely, observe detail and engage with the natural world. It works for me!

Here are some, but by no means all, of the charities and groups that help with the conservation of the UK's fauna, flora and habitats, including our hay meadows:

ARC 2020: www.arc2020.eu
Buglife: www.buglife.org.uk
Field Studies Council:
 www.field-studies-council.org
The Floodplain Meadows Partnership:
 www.floodplainmeadows.org.uk
Flora Locale: www.floralocale.org
Friends of the Earth: www.foe.co.uk
The Grasslands Trust: www.grasslands-trust.org
National Parks: www.nationalparks.gov.uk
Natural England: www.naturalengland.org.uk
The Wildlife Trusts: www.wildlifetrusts.org
WWF: www.wwf.org

Index

Page numbers in *italic* type refer
to illustrations

adder's tongue fern 9, 42
Africa 43
Agrostis stolonifera 100
Anacamptis morio 74–5
Anthriscus sylvestris 88
ants 83
Araneus diadematus 81, 100
Araniella cucurbitina 88
aphid *88*
Aphidoidea 88
ash 28, 121

badger 9
banded demoiselles 82
bats 83
Berks, Bucks & Oxon Wildlife
 Trust 7
bee orchid 61–3, *68*
bees 9, 81–2
beetles 8–10, 82
birds 8–9, 29, 42–5, 81, 105, 118,
 120
bird's-foot trefoil 82
blackberry 9, *49*, 105, *115–16*,
 121
blackbird 44
blackthorn 8, 42–3, 45, 48, 82,
 114
Blakehill Farm 121
bluebell 42, 105
bluebottle 81, *84*
Bos taurus 123–4
brandy bottle water lily *92*
Braydon Forest 6–7
brown hairstreak 82
bumblebees 81
burnt tip orchid 60, 62–3, 67
buttercup 62
butterflies 8–10, 82–3
buzzard 43

Calliphora vomitoria 81, 84
Caltha palustris 31
canary reed grass 28, *52*
catsear 80
Centaurea nigra 24, 58
Cecidomyiidae 85
chaffinch 43
Chimney Meadows 7
chimney sweeper 83
Cirsium palustre 109
cleavers 121
Closterotomus norwegicus 58
cockscomb 104
cocksfoot *19*, 60
common agrimony 105
common blue butterfly 82, *98*
common blue damselfly *15, 47,
 78, 82, 86, 113*
common hazel *116*
common knapweed *24, 58*, 62,
 104

common sorrel *109*
common spotted orchid *24,
 62–3, 67–8, 72*, 78
corn bunting 45
Corylus avellana 116
County Durham 6
cow parsley *88*
cows 10–11, 118, 121, *123–4*
cowslip 28–9, *30*, 121
Crataegus monogyna 31, 49, 115
creeping bent 60, *100*
crested dog's tail 46, 60, 105
Cricklade 29
cuckoo 44, 83
cucumber spider 81–2, *88*
Culicidae 88
Cumbria 6
Cynosurus cristatus 46

Dactylis glomerata 19
*Dactylorhiza fuchsii 24, 67–8, 72,
 78*
Dactylorhiza incarnata 72
Dactylorhiza praetermissa 68, 72
damselflies 8
dandelion 104–5, *110*
deer 28
devil's bit scabious 8, *20*, 47, 83,
 98, 105
dog rose 28, *54*
dragonflies 8–9, 44, 81–2

early marsh orchid 62–3, *72*
*Enallagma cyathigerum 15, 47,
 78, 86, 113*
Eupatorium cannabinum 15
European rabbit *4*, 9
Festuca arundinacea 78
fieldfare 44, 118
Filipendula ulmaria 23, 51
flies 8–9
four-spotted chaser 9, *91*
fox 9, 28
Fritillaria meleagris 28–9, 35–9
froghopper 10, 82
fungi 63

Galium verum 58
gall gnat 81, *85*
goat's beard 104, *110*
grasshoppers 10
great burnet 9, 11, *24*, 81
great bustard 45
green winged orchid 9, 62–3,
 74–5
grey partridge 45
grey willow 44
guelder rose 28, 80, *93, 115–16*

hawkbit *24, 58*, 80, 83, *113*
hawthorn 8, 28, *31*, 42, 45, *49*,
 105, *115*
Helictotrichon pratense 109
hemlock water dropwort 57
hemp agrimony 15

heron 43
hobby 9, 44
Holcus lanatus 46
honeybees 81
horseflies 81
hoverflies 81

insects 80–83
ivy 105

Jack-go-to-bed-at-noon 60,
 104–5, *110*

lady's bedstraw 83
Leontodon 24, 58, 113
Leontodon hispidus 88
lesser celandine *30*
Libellula quadrimaculata 91
long-tailed tit 43
Lychnis flos-cuculi 23

magpie 43

Maniola jurtina 24
marsh fritillary 83
marsh marigold *31*
marsh thistle *109*
meadow brown *24*
meadow buttercup *19, 50*
meadow oat grass 104, *109*
meadowsweet 11, *23, 51*
Mediterranean bumble bee
 orchid 61
milkwort *55*
mosquito *88*
moths 82–3

Natural England 29
Neotinea ustulata 60, 67
netted adder's tongue fern 42
nightingale 43
North Meadow 29
Nottinghamshire Wildlife Trust 7
Nuphar lutea 92

oak 28
Oenanthe crocata 57
Ophioglossum reticulatum 42
Ophioglossum vulgatum 42
Ophrys apifera 61, 68
Ophrys apifera trolli 61–2, 73–4
Ophrys bombyliflora 61
orchids 9, 29, 60–63
Oryctolagus cuniculus 4
ox-eye daisy 105
Oxfordshire 7

pepper saxifrage 62
Phalaris arundinacea 52
plantain 60, 62
Polygala vulgaris 55
Polyommatus icarus 98
poplar 8
potato caspid 58
Primula veris 30
Prunus spinosa 48, 114

ragged robin 23
Ranunculus acris 19, 50
Ranunculus ficaria 30
red campion 42
red clover 105
red fescue 60
redwing 44, *52*
reed bunting 28
River Thames 6
robber flies 81
robin 121
roe deer 9
rook 118
Rosa canina 54
rough hawkbit *88*
Rubus fruticosus 49, 115–6
Rumex acetosa 109
rush 8, 11, 28, 62, 81, 118

salix *52*
salsify 104
Sanguisorba officinalis 24
Scathophaga stercoraria 91
scorpion fly 80
sheep 10, 121
six-spot burnet *87*
skylark 45, 82
snake's head fritillary 28–9,
 35–9, 82, 121
southern marsh orchid 9, 62–3,
 68, 72
spiders 81
stitchwort 121
Succisa pratensis 20, 47, 98
swift 83

tall fescue *78*
Taraxacum officinale 110
Tetragnatha extensa 82, 96
thrush 43–4
Tragopon pratensis 110
tree sparrow 45
twayblade 62
tufted vetch 8, *21*, 105
Turdus iliacus 52
Viburnum opulus 93, 115–6

wasp orchid 61–3, *73–4*
wasps 9
willow 8, 28–9, 42, *52*, 80
Wildlife Trusts, the 6–7, 9, 120
Wiltshire Wildlife Trust 6–7, 9,
 120–21
wolf spider 82

yellow bedstraw *58*
yellow dung fly 80–81, *91*
yellow flag iris 28, 105
yellow rattle 104
yellow wagtail 10
yellow water lily *92*
Yorkshire fog 46, 60

Zygaena filipendulae 87